CERAMIC ART FROM BYZANTINE SERRES

Ceramic Art from Byzantine Serres

Demetra Papanikola-Bakirtzis
Eunice Dauterman Maguire
Henry Maguire

Contributions by
Charalambos Bakirtzis and Sarah Wisseman

Illinois Byzantine Studies III

UNIVERSITY OF ILLINOIS PRESS
Urbana and Chicago

This book is printed on acid-free paper.

Library of Congress Cataloging-in-Publication Data
Papanicola-Bakirtzē, Dēmētra.
 Ceramic art from Byzantine Serres / Dēmētra Papanikola-Bakirtzis,
Eunice Dauterman Maguire, Henry Maguire ; contributions by
Charalambos Bakirtzis and Sarah Wisseman.
 p. cm. — (Illinois Byzantine studies ; 3)
 Catalogue of an exhibition held at the Krannert Art Museum,
Urbana, Ill.
 Includes bibliographical references.
 ISBN 0-252-06303-1 (pb : acid-free paper)
 1. Luster-ware—Greece—Serrai—Exhibitions. 2. Pottery,
Byzantine—Greece—Serrai—Exhibitions. 3. Graffito decoration—
Greece—Serrai—Exhibitions. 4. Ephoreia of Byzantine Antiquities
(Kavala, Greece)—Exhibitions. I. Maguire, Eunice Dauterman,
1943- . II. Maguire, Henry, 1943- . III. Krannert Art Museum.
IV. Title. V. Series.
NK4280.P76 1992
738.3'09495'65—dc20
 92-21776
 CIP

CONTENTS

List of Illustrations vii

Preface ix

1 Byzantine Pottery in the History of Art 1
 Eunice Dauterman Maguire and Henry Maguire

2 Serres: A Glazed-Pottery Production Center during the
 Late Byzantine Period 21
 Demetra Papanikola-Bakirtzis

3 A Note on the History and Culture of Serres during the
 Late Byzantine Period 36
 Charalambos Bakirtzis

 Catalogue Entries 41

4 The Materials Analysis of Byzantine Pottery 66
 Sarah Wisseman

 Glossary 70
 Selected Bibliography 72

ILLUSTRATIONS

Color Plates

I. Plate produced and found at Serres (catalogue no. 1). Colored Sgraffito ware. *5*

II. Plate produced and found at Serres (catalogue no. 7). Colored Sgraffito ware. *6*

III. Bowl produced and found at Serres (catalogue no. 20). Colored Sgraffito ware. *7*

IV. Bowl produced at Serres and found at Maroneia (catalogue no. 23). Colored Sgraffito ware. *8*

Figures

1. Mosaic of St. Paul, early fourteenth century. Monastery Church of the Chora (Kariye Camii), Istanbul. Source: Dumbarton Oaks. *2*

2. Mosaic of St. Paul, early eleventh century. Monastery Church of Hosios Loukas. Source: Henry Maguire. *2*

3. Byzantine ceramic bowl, fourteenth century (?). Boston Museum of Fine Arts. Source: Henry Maguire. *3*

4. Byzantine ceramic bowl from Serres, late twelfth century. Ephoreia of Byzantine Antiquities, Kavala. Source: Ephoreia of Byzantine Antiquities, Kavala, Greece. *10*

5. Byzantine ceramic bowl, twelfth century. Walters Art Gallery, Baltimore. Source: Walters Art Gallery. *10*

6. Ceramic bowl from Syria, twelfth-thirteenth century. Ashmolean Museum, Oxford. Drawing after J. W. Allan, *Islamic Ceramics* (Ashmolean Museum, Oxford, 1991), pl. 43a. *14*

7. Ceramic bowl from Iran, second half of the twelfth century. From the collection of Sir Alan Barlow. Drawing after A. Lane, *Early Islamic Pottery* (London, 1947), pl. 48. *14*

8. Sgraffito patterning of ceramic bowl from Nishapur, ninth century. The Metropolitan Museum of Art, New York. Drawing after A. Lane, *Early Islamic Pottery* (London, 1947), pl. 6B. *14*

9. Ceramic bowl from Iran, tenth-eleventh century. Louvre, Paris. Drawing after *Arts de l'Islam des origines à 1700* (exh. cat., Orangerie des Tuileries, Paris, 1971), no. 22. *15*

10. Bronze bowl, inlaid with silver, from northern Syria or Jazira province, thirteenth century. Ashmolean Museum, Oxford. Drawing after M. Vickers, O. Impey, and J. Allan, *From Silver to Ceramic* (Oxford, 1986), pl. 65. *16*

11. Three-legged dish from China, Tang period. Ashmolean Museum, Oxford. Drawing after M. Vickers, O. Impey, and J. Allan, *From Silver to Ceramic* (Oxford, 1986), pl. 37. *17*

12. Wooden mallet for pulverizing earth. Source: Ephoreia of Byzantine Antiquities, Kavala, Greece. *22*

13. Traditional workshop with a foot-operated wheel on the island of Thassos. Source: Ephoreia of Byzantine Antiquities, Kavala, Greece. *22*

14. Vessel decorated with a bird. Fine-Point Sgraffito. From Synaxis-Maroneia in Thrace, mid-twelfth century. Source: Ephoreia of Byzantine Antiquities, Kavala, Greece. *23*

15. Vessel with engraved sgraffito decoration. From Thessaloniki, second half of twelfth century. Source: Ephoreia of Byzantine Antiquities, Kavala, Greece. *24*

16. Clay tripod stilts. Source: Ephoreia of Byzantine Antiquities, Kavala, Greece. *26*

17. Vessels stacked with tripod stilts in between. Source: Ephoreia of Byzantine Antiquities, Kavala, Greece. *26*

18. Slip-painted decoration on the exterior surfaces of vessels from Serres. Source: Ephoreia of Byzantine Antiquities, Kavala, Greece. *28*

19. Slip-painted decoration on the exterior surfaces of vessels from Serres. Source: Ephoreia of Byzantine Antiquities, Kavala, Greece. *28*

20. Various guilloches from Serres pottery. Source: Ephoreia of Byzantine Antiquities, Kavala, Greece. *30*

21. Fragments of clay rods and S-shaped devices from Serres. Source: Ephoreia of Byzantine Antiquities, Kavala, Greece. *32*

22. Reconstruction of a kiln with clay rods to support the vessels. Source: Ephoreia of Byzantine Antiquities, Kavala, Greece. *32*

23. The distribution of Serres pottery. Source: Ephoreia of Byzantine Antiquities, Kavala, Greece. *33*

24. Icon of Christ from the Monastery of St. John Prodromos. Source: Ephoreia of Byzantine Antiquities, Kavala, Greece. *37*

25. Mosaic of the Communion of the Apostles. Old Metropolis, Serres. Source: Ephoreia of Byzantine Antiquities, Kavala, Greece. *38*

26. Marble Icon of Christ Euergetes. Archaeological Museum, Serres. Source: Ephoreia of Byzantine Antiquities, Kavala, Greece. *39*

27. Cluster diagram of the samples from Serres. *68*

PREFACE

This catalogue accompanies the exhibition of an important collection of twenty-five Byzantine ceramics from the Ephoreia of Byzantine Antiquities at Kavala, a branch of the Greek Archaeological Service. The ceramics come from recent archaeological excavations in northern Greece, and therefore have a more definite provenance than most of the pieces in museum collections, which were purchased on the art market. In addition, these ceramics are all the products of an identified workshop, at Serres, from a specific time period, the thirteenth to the fourteenth centuries. For this reason, they are extremely interesting not only as records of local taste, but also as illustrations of how medieval pottery was made. Excavations at the actual sites of pottery production discovered discarded failures, or "wasters," unfinished pieces that reveal the stages of production to the modern archaeologist. The material from Serres even includes objects such as the rods used to separate the clay pots within the kiln.

This exhibition is the result of continuing fruitful relations between the University of Illinois at Urbana-Champaign and the Ephoreia of Byzantine Antiquities in Kavala. For proposing and creating this uniquely defined exhibition, we are most grateful to Demetra Papanikola-Bakirtzis, curator at the Ephoreia of Byzantine Antiquities in Kavala, and to the ephor, Charalambos Bakirtzis. We thank the Government of Greece, through the Greek Archaeological Service, for making it possible. We also thank the director of Krannert Art Museum, Stephen S. Proko-poff, for making the exhibition a project of the museum.

An important aspect of the research leading up to the exhibition has been the testing of the clays and glazes of a group of ceramics with the help of the Program for Ancient Technologies and Archaeological Materials of the University of Illinois at Urbana-Champaign, under the direction of Sarah Wisseman. To her, and to everyone participating in the project, we owe a great debt of gratitude. We thank Sheldon Landsberger and the Department of Nuclear Engineering at the University

of Illinois for carrying out the work of neutron activation analysis at the university's reactor facility in order to determine the elemental compositions of the clays, and William Cizek for clustering the samples, so that their sources may be identified from the resulting "fingerprints."

We are most grateful to the staff of the Ephoreia of Byzantine Antiquities in Kavala for preparing the items for the exhibition and particularly to Photini Kondakou and Theodoros Damianou for producing drawings and plaster reconstructions respectively. We are greatly indebted to Gavin Maguire for the drawings that illustrate the first chapter, and to Mary Kelton Seyfarth for making pottery models of the several stages of production for the exhibition. Our list of acknowledgments would be incomplete without thanks to Hedy Schiller and Joyce Zillig MacFarlane for help in preparing the manuscript for publication, and to the staff of Krannert Art Museum for bringing the exhibition physically into being. We are also grateful to the staff of the University of Illinois Press, in particular to Elizabeth Dulany, the associate director, and to Carol Bolton Betts, our editor.

We believe that this is the first exhibition in North America to be devoted to Byzantine pottery. There have been very few exhibitions anywhere devoted to Byzantine ceramics, due in part to the wide dispersal of the material and to an earlier lack of research on the subject. Increasingly, however, scholarly attention is being paid to Byzantine ceramics, and a greater understanding is being gained of their importance, not only within Byzantine civilization but within the whole development of medieval and later ceramic art. For these reasons, more than the usual credit is due to the colleagues and supporters whose aid has been essential in bringing this project to fruition: Susan Boyd, Sheila Campbell, Maggie Duncan-Flowers, Margaret Frazer, Angeliki Laiou, Nancy Netzer, Robert Ousterhout, Jane Ayer Scott, Gary Vikan, William Wixom, and Stephen Zwirn. We also wish to thank our funding agencies, the American Ceramic Circle, the Research Board of the University of Illinois, and an anonymous donor, without whose aid neither the exhibition nor this catalogue would have been possible.

It remains for us to outline the plan of this book. The first chapter, written by Eunice Dauterman Maguire and Henry Maguire, places Byzantine pottery in the wider context of the history of art. In the second chapter Demetra Papanikola-Bakirtzis discusses Serres as a pottery-producing center during the Late Byzantine period, with particular reference to the technical aspects of the production of Byzantine pottery. The third chapter, by Charalambos Bakirtzis, gives an overview of the history and culture of Serres in Late Byzantine times. These three chapters are followed by a catalogue of the pieces in the exhibition. The inventory work for the entries was done by Demetra Papanikola-Bakirtzis, who was also responsible for the reconstruction and selection of items for the exhibition. Her descriptions have been supplemented by Eunice Dauterman Maguire. A final chapter, written by Sarah Wisseman, presents the results of the materials analysis of the Serres pottery.

Eunice Dauterman Maguire
Henry Maguire

CERAMIC ART FROM BYZANTINE SERRES

1

BYZANTINE POTTERY IN THE HISTORY OF ART

Eunice Dauterman Maguire and Henry Maguire

FREEDOM AND INVENTION

This exhibition runs against our century's prevailing views of Byzantine art. One of them is that Byzantine "creative faculties . . . were mainly guided by the mystic and inspirational."[1] Another is that the art derives unearthly qualities revealing "the Byzantine mentality" in the artist's adherence to strict conventions of formal control, the opposite of spontaneous expression standing for the achievement of an entire civilization.[2] A third accepted belief has been, to put it at its ambiguous best, that Byzantium, "well into the fourteenth century," exercised "restraining and sustaining forces" on a decline in the arts.[3] Byzantium still is justly famous for its religious art, and especially for its devotional icons. The conservative forms of the icon, deeply in tune with the requirements of Byzantine ritual and devotion, have the ability to move viewers on many levels, aesthetic, emotional, and spiritual. But there is another aspect of Byzantine art that is almost totally unknown to nonspecialists today, namely the wealth of glazed ceramics that were produced in great quantity and variety between the ninth and fifteenth centuries. These ceramics—the plates, bowls, and jugs used in Byzantine households—contradict the commonly held perceptions of Byzantine art.

The exhibition also takes a fresh look at a relatively despised art form, objects made of inexpensive materials and produced in quantity for household use.[4] For the most part the designs on the domestic pottery are not religious but secular, and they were not governed by the restraints and conventions that controlled the production of church art. On the contrary, the art of the Byzantine potter was inventive and individualistic; the techniques were innovative, the shapes varied, and the designs lively. Often the artists who engraved Byzantine ceramics drew upon popular culture for their inspiration, or upon the decorative vocabulary of Iran and the Islamic Near East. Frequently, also, they drew upon their own imaginations,

producing idiosyncratic designs that are the antithesis of the regulated productions of Byzantine ecclesiastical art.

A famous passage from the acts of the Seventh Ecumenical Council, held at Nicaea in 787, states: "The making of icons is not the invention of painters, but [expresses] the approved legislation of the Catholic Church. . . . for the painter's domain is limited to his art, whereas the disposition manifestly pertains to the Holy Fathers. . . ."[5] In other words, the Byzantine artist who depicted religious subjects had to keep the designs within certain limits, which were prescribed by the traditions of the Church. There were established formulas that dictated the composition of important scenes (such as the major events of Christ's life) and the portrait types of major saints (such as the apostles and the major Church Fathers). Of course, there was some room for variation and individual artistic expression, but the overall parameters were fixed. The point can be made by a comparison of a mosaic of St. Paul from the early fourteenth-century decoration of the church of the Chora monastery (the Kariye Camii) in Constantinople (now Istanbul) (fig. 1), with a mosaic of the same saint made some three hundred years earlier in the monastery church of Hosios Loukas, in Greece (fig. 2). Though the styles of the two mosaics are quite different, expressing the work of two different artists working at two different times, the portrait types and the costumes are essentially the same: in each case one can compare the long dark beard; the elongated face; the high, balding

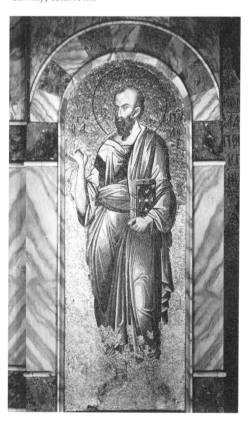

Fig. 1. Mosaic of St. Paul, early fourteenth century. Monastery of the Chora (Kariye Camii), Istanbul.

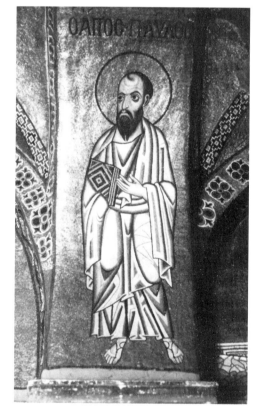

Fig. 2. Mosaic of St. Paul, early eleventh century. Monastery of Hosios Loukas.

forehead; and even the curl at the temple. In each mosaic the apostle wears the antique tunic and himation, and carries a bound book in the crook of his arm.

The Byzantine potter, on the other hand, was free of the artistic restraints imposed by his church. Except for the ceramic tiles made expressly for the decoration of churches, the subjects depicted by the potter were overwhelmingly secular and frequently were characterized by a striking freedom of invention and design. Often Byzantine potters created fantastic forms, combining the parts of different animals and plants. Some of these hybrid creations, such as the griffin, the centaur, the harpy, and the sphinx, were derived from ancient Greek art and mythology; others, such as the so-called Chinese "phoenix," came out of the repertoire of lands to the east. Still others came from the potters' imaginations (fig. 3). Even if we look only at the birds depicted on the pottery from Serres (catalogue nos. 1-6), a town in Macedonia in the north of Greece, we find a wide variety of composite creatures; the depictions of the birds keep to certain conventions, individually, but the details of no two are alike. In their style, too, Byzantine ceramics make a striking contrast to the mosaics and paintings of Byzantine churches. The art seen here is not the tightly confined, prescribed art of the icon; instead it relies largely on accident and improvisation—qualities attributed more often to post-Renaissance than to medieval art. The drawing of the figures is often free and sketchy rather than ordered and contained, while the application of color, for technical reasons to be explained

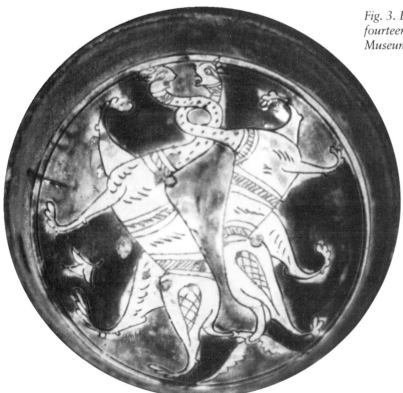

Fig. 3. Byzantine ceramic bowl, fourteenth century (?). Boston Museum of Fine Arts.

3

below, tends to have a splashed-on, impressionistic quality, very different from the hard-edged precision of much ecclesiastical painting.

TECHNIQUE AND AESTHETIC

The majority of the pottery that survives from Byzantium is tableware, intended for private domestic use. It is, therefore, a form of popular art, produced by professionals but addressed to a widespread public. Its being in common use did not result in disregard for its artistic qualities, for in Italy as well as in Greece, actual bowls were set into the masonry on the exterior facades of churches for their decorative color. All of the pieces in this exhibition are colored sgraffito ware, although several were left unfinished and discarded before the color was applied. Sgraffito decoration was achieved by the engraving of thin or broad lines in the covering slip to expose the darker body of the biscuit. Although the continued use of the pale-colored slip as a coating over the darker clay may owe its ultimate origins to admiration of the white body of Chinese porcelains, which in this general period were often carved and then covered with a clear glaze, the rich tastes of the later Byzantine period tended toward the love of color and motion in greater exuberance than Chinese ceramics, for all their refinement, could provide. The pale ground of the slip showed off colors to good effect. From the late twelfth century onward, many Byzantine potters colored their sgraffito designs with yellow-brown (iron oxide) and green (copper oxide) tints. The Byzantine potters employed two types of colored sgraffito, One Color Sgraffito and Brown and Green Sgraffito. At the beginning, from around the turn of the twelfth and thirteenth centuries, Byzantine potters only used one color, either yellow-brown or green, to color their designs. The elegant Zeuxippos wares, named after their original findspot at the baths of Zeuxippos in Constantinople, are fine examples of One Color Sgraffito.

Subsequently, during the thirteenth and fourteenth centuries, Byzantine potters used two colors together, often overlapping on the same vessel, producing a richer effect. Characteristic of these colors is their splashy, untrammeled vivacity of application; the combined forces of color and line can spin the surfaces into dynamic motion. They look freely brushed, almost impressionistic in their disregard of hard outlines, setting up a counterpoint like that of animated, colored shadows with the underlying engraved decoration. This sunshine-and-shadows effect is the result of the colors fusing with the lead glaze and running during the firing process. It enforces a charming, improvisational style in which the potter must design the color application loosely, not always being able to control precisely the spreading or confinement of the colors. No other Byzantine artists in this period permitted themselves this kind of freedom from a predetermined pattern. The potters exploited to the full the "impressionistic" effects produced by the running of the colors, often creating an attractive tension between the deliberate, sharp-textured drawing, delineated in sgraffito, and the splashed-on, exuberant colors, the yellow and green. The color schemes against the white ground play with many kinds of alternation, often in combination on one vessel: centrifugal or radial, confined to

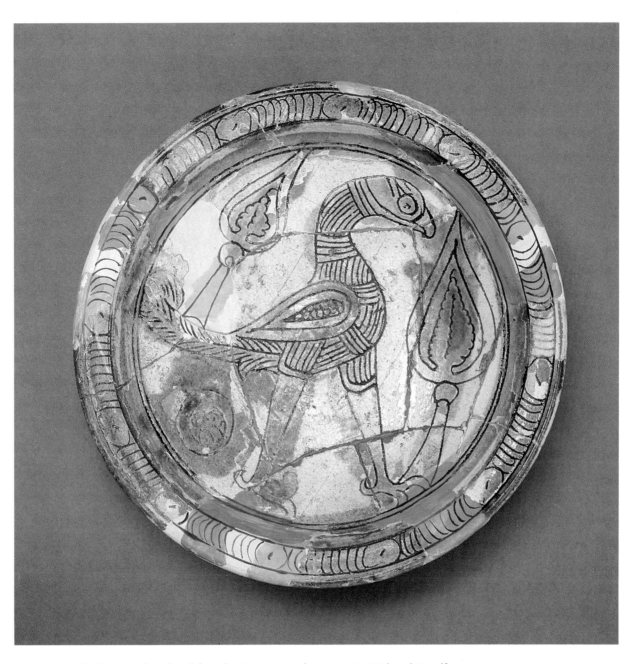

I. Plate produced and found at Serres (catalogue no. 1). Colored Sgraffito ware.

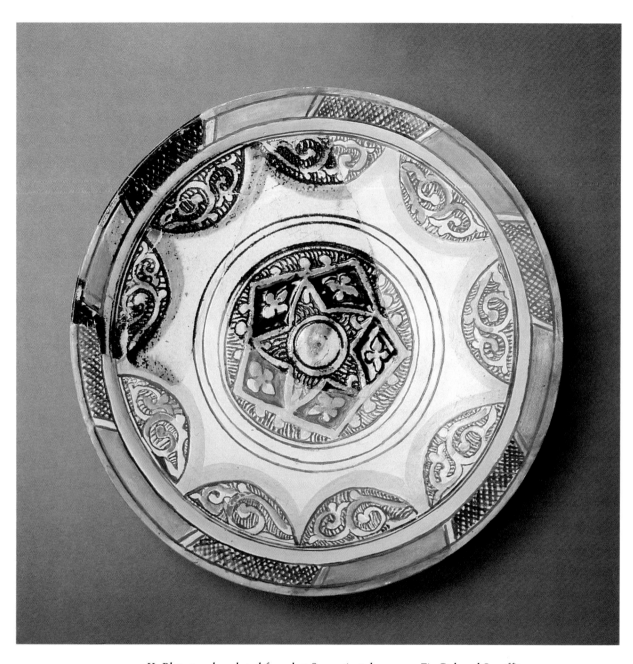

II. Plate produced and found at Serres (catalogue no. 7). Colored Sgraffito ware.

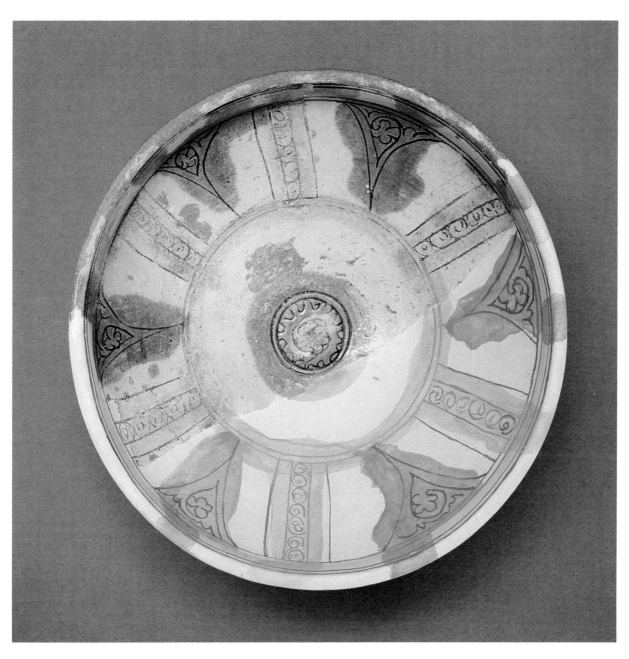

III. Bowl produced and found at Serres (catalogue no. 20). Colored Sgraffito ware.

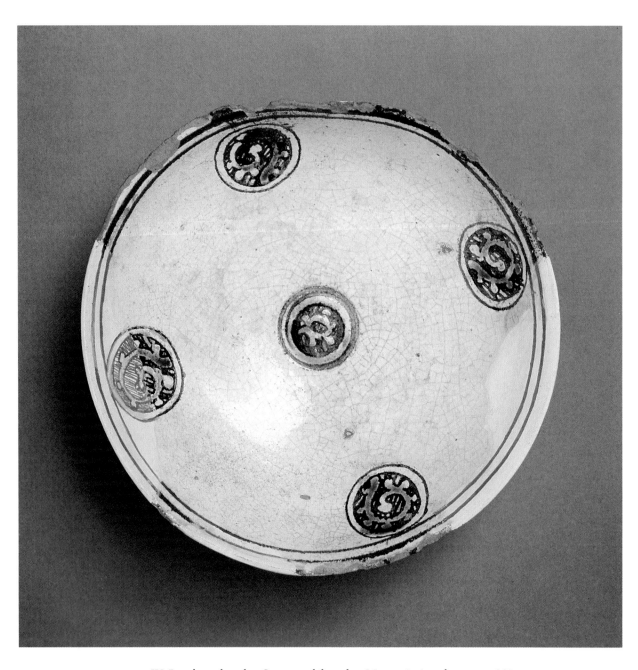

*IV. Bowl produced at Serres and found at Maroneia (catalogue no. 23).
Colored Sgraffito ware.*

one area or shifting from one to the next, or even creating an asymmetrical counter-poise. They articulate a hierarchy of dominant and secondary units, or divide vessel surfaces, by color-coding, into zones. They resolve the engraved designs into chromatic rhythms that are highly sophisticated in spite of their splashiness. A few of the vessels in the catalogue will illustrate this aspect of the decoration at Serres. Number 20 (color plate III) features a centrifugal/centripetal alternation, with yellow at the very center of the green palmette in the medallion, surrounded in turn by yellow spreading beyond the medallion, into the white field; the wheel-like circle and its banded spokes, the principal dividers radiating outwards, are all green, while the triangular spandrels under the rim flow with yellow down toward the center. Numbers 7, 8, 18, and 21 also employ strong alternating color patterns within each zone of their respective designs. These colors become an active and dynamic perceptual force, much more than simply a tonal addition or a motley overlay.

Another good example of this aesthetic is the plate with an imaginary bird (catalogue no. 1 and color plate I). This piece has a red clay body, with white slip applied to the inside, on which there are yellow-brown and green color splashes, under a clear glaze. The potter has first created the bird in the sgraffito technique by engraving into the slip to reveal the clay body. The bird stands between a pair of emblematic, spearlike trees, in which a single leaf inside a leaf-shaped frame stands for all the foliage. These shapes, and the striations of the border, are strongly defined and clearly drawn by linear means, so as not to be overwhelmed by the strong counter-point of running color. As if to acknowledge the color's capriciousness, the potter alternates playfully between the yellow and the green: one tree is only yellow, the other partly green; one leg of the bird is yellow, and the other green; the bird's head and neck are yellow, while its wing is green. Yet, since none of these colors keeps to the outlines of the incised form, the colors are suggestive rather than absolute. They seem to move like the passage of light, in a way that counteracts the flatness of the image. They set up their own off-center balance, reinforced by the asymmetrical application of colors to the rim.

NATURE AND DESIGN

Byzantine potters liked to decorate their wares with subjects taken from the world of nature, with animals and with plants, freely drawn and often brightly colored. They also borrowed themes from popular life, depicting such subjects as musicians, dancers (fig. 4), hunters, and warriors. They illustrated contemporary romances, such as the poems describing the deeds of a mythical frontiersman, Digenis Akrites. Sometimes they incised apotropaic signs, such as the so-called knot of Solomon, which had the power to avert evil from the meal or from the house in which the ceramics were used. The pottery from the workshop at Serres vividly illustrates the fondness of Byzantine potters for motifs taken from nature. Generally speaking, Byzantine ceramics portray nature in one of two aspects, showing either its destructive powers or its gentler delights. Often the plates and bowls are decorated with rapacious creatures, such as lions, leopards (fig. 5), or hawks with their prey. In Byzantine culture such animals were talismans, invested with a protective

9

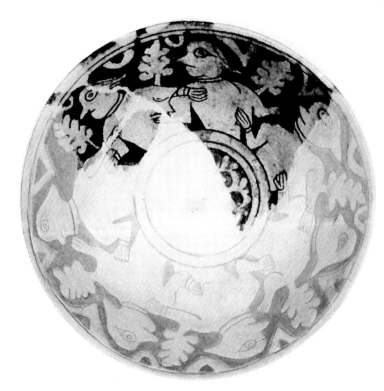

Fig. 4. Byzantine ceramic bowl from Serres, late twelfth century. Ephoreia of Byzantine Antiquities, Kavala.

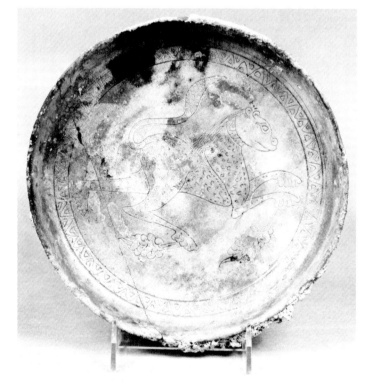

Fig. 5. Byzantine ceramic bowl, twelfth century. Walters Art Gallery, Baltimore.

significance: their strength and destructive powers could be put to work on behalf of the owner or the user of the vessel, to guard him or her from harm. For this reason the Byzantines used to carve fierce creatures above doorways, to keep evil from entering; even the doors of Christian buildings were protected in this way. On another level, the plates with hawks evoked an aristocratic form of hunting, while the lions and leopards evoked the imagery of the court, where such beasts were used as symbols of imperial strength and prestige. The presence of these exotic creatures on relatively common earthenware expressed a desire to emulate the luxuries of the powerful.

The other aspect of nature that appears on Byzantine pottery is the evocation of its charms, expressed by colorful birds, flowers, vines, and leafy trees (see especially catalogue nos. 1-6, 11-13, and 23, and color plates I and IV). On some vessels (such as catalogue no. 19) the leaves are rotating so as to resemble the "windblown" leaves of early Byzantine architectural sculpture or the still more ancient foliage arranged with alternate curling tendrils around the bodies of Hellenistic silver bowls.[6] In its simplest form this Mediterranean love of motion expresses itself in the pure abstract line of the spiral coil at the center of catalogue number 17, made while the potter's wheel was still turning.

The Byzantines also expressed their pleasure in nature in their secular literature, such as the romances and the rhetorical descriptions of springtime. Typical of the latter genre is this tenth-century poem by John Geometres, which describes a garden near Constantinople:

> The earth is arrayed like a bride, . . . coming forth brightly adorned in every plant, with laurels, with young shoots, with bushes, with vines, with ivy clusters, and with fruit-bearing trees . . . with all flowers, all beauties, every scent, every complexion . . . with rose beds, lilies, scented violets, chrysanthemums, sweet narcissi, and crocuses. . . . Everything rejoices, . . . everything takes delight, everything sings. . . .[7]

More rarely, the pottery shows the interaction of humans and nature, as in a fragment of a late twelfth-century bowl found at Serres (fig. 4). Before a background of trees or branches, it depicts figures in a round dance, who may be celebrating a festival in the countryside; the "U" and "V" shapes at the rim suggest hanging garlands, the decorations of an outdoor feast, while the bottom of the bowl is a medallion with floral motifs.

As was suggested at the beginning of this essay, one of the most characteristic aspects of Byzantine pottery design is a willingness to play with the elements of nature, to make up new forms by combining different creatures and plants (fig. 3). This aspect of the potter's art may be seen on the plate with the bird between two trees (catalogue no. 1 and color plate I). On this piece, the artist has engraved a creature that is a strange hybrid; it has the curved beak, the powerful legs and claws of an eagle, but at the same time a graceful neck and long tail such as might appear on a peacock, a pheasant, or even the mythical bird known as the phoenix, as it was depicted in Chinese art and in its Byzantine imitations.[8] Such hybrid creatures and plants reveal a delight in mixed forms that was expressed in other aspects of Byzan-

tine secular life. For example, the Byzantine agricultural treatise the *Geoponika,* a compilation of the tenth century, gives instructions for creating fruits in the shapes of birds or animals, by growing them in molds made of plaster or clay.[9] A similar inventiveness is revealed by a twelfth-century letter of Michael Italikos, in which he describes an imaginary banquet with such delicacies as fish fashioned in the shapes of birds, and birds molded as fishes.[10] It is to tastes such as these that the Byzantine potter responds, evoking a world far removed from the canons of Byzantine religious art.

We see, then, that the ceramics from Serres, presented in this exhibition, are typical of Byzantine pottery in portraying the two aspects of nature. Flowers and trees appear with birds; however, the characteristics of the birds are often those associated with raptors, such as eagles. Strong talons and curved beaks speak of power, even while foliage and color add their grace.

COMMERCE AND DIFFUSION

The importance of Byzantine ceramics goes beyond their lively visual appeal and the light they throw on Byzantine secular culture, for the trade in pottery during the Middle Ages was international, and Byzantine ceramics were at the center of a wide network of interchange. Contacts between Byzantium and Islam were close. There were even Muslim communities within the Byzantine empire, and a mosque is attested in Constantinople and possibly also in Athens.[11]

At Byzantine Corinth excavators found wares from a variety of Islamic lands as well as proto-maiolica ware, thought to have come from Italy, and a piece of Chinese porcelain.[12] It may be that potters traveled as did pottery, and the presumed ethnicity of pots and potters need not have coincided. Byzantine pottery itself was produced at many centers and was widely distributed within the empire as well as traded beyond its borders. From archaeological discoveries and from shipwrecks it is evident that Byzantine pottery was sent to markets far from its centers of production. From archaeology, we now know that the places in which Byzantine pottery was made included Corinth, Thessaloniki, Serres, and Didymoteichon in Greece; Paphos, Enkomi, and Lapithos on the island of Cyprus; and probably Constantinople, the empire's capital. Written sources tell us of the existence of small village workshops, containing two or three potters.[13] The products of Byzantine workshops have been found in Constantinople, as well as in the Balkan peninsula, in Anatolia, in Syria, in Palestine, and in northern Italy. Even as far north as the Rhineland, the early-twelfth-century monk Theophilus, writing his treatise for artists and craftsmen, knew of Byzantine polychrome wares.[14] The wide diffusion of Byzantine pottery made it an important medium for the transmission of ceramic technology from the eastern Mediterranean to western Europe. Because of their geographical position between the Islamic world and western Europe, the Byzantine potters played a vital role in the development of western European ceramic technology, especially in the introduction of techniques of glazing, decoration, and firing associated with sgraffito ware.

12

At first the shipping of Byzantine pottery to the West was carried out by the Byzantines themselves, but during the period of the Crusades, in the twelfth and thirteenth centuries, the Italian mercantile cities of Genoa and Venice increasingly controlled the trade in Byzantine ceramics. The involvement of these cities in the pottery trade, and the European taste for goods from the East, facilitated the introduction of Byzantine pottery and its techniques into Italy. The trade in pottery was carried in wooden ships. Fortunately for modern historians (but unfortunately for medieval merchants) many of the cargo ships that plied the Mediterranean sank with their cargoes before they reached their destinations. Several of these ill-fated vessels have been discovered in recent times off the coasts of Greece and Turkey. Notable shipwrecks of Byzantine vessels loaded with pottery have been found off the islands of Kastelorizo and Alonysos.[15] These shipwrecks vividly testify to the importance of ceramics in international commerce. The influence of Byzantine pottery on ceramic production was especially important in northern Italy, particularly in Venice, where potters in the first half of the thirteenth century began to imitate imported Byzantine sgraffito wares.[16] From Venice the technique spread to other centers in northern Italy, where it was adapted to the demands of early Renaissance patrons.

BYZANTINE POTTERY AND THE EAST

Although the repertory of Byzantine sgraffito pottery developed out of its past, at any moment in its history it was also tied to the work of potters east of the empire. We are not speaking here of the direct imitation of oriental ceramics by Byzantine potters, but of associated principles of design that link Byzantine pottery closely to the traditions of the Islamic world and even, in some instances, of China. These design principles appear more strongly in Byzantine secular art than in its religious art, which was more dependent upon the Greco-Roman traditions of figural composition. In the following pages we will explore, through the Serres pottery, the relationships of Byzantine ceramics to the design traditions of the Near and Far East. We may start with the patterning of catalogue number 7 (color plate II), which, although incised, in several respects resembles glazed and painted pottery attributed to Syrian and Iranian potters of the twelfth and thirteenth century. Its central medallion surrounded by a white ring inside a double circle, with an elaborate polygon and star pattern on a ground hatched to imitate textured metalwork, has these features in common with an Iranian pottery bowl from Kashan, made in the Mongol years of the late thirteenth century.[17] Beyond the central ring, the surface of the Serres plate develops into a cusped, star-shaped field of nine points enclosing a scalloped border of semicircles filled with sprigs of vegetation whose stems all curve in one lateral direction, as if to spin the rim of the vessel into rotation around and between the radial points. This same design scheme, even to the number of nine cusps, surrounds the radial center of an underglaze-painted Syrian bowl of the twelfth to thirteenth century (fig. 6).[18] In one case the direction is clockwise (the Serres plate), and in the other counterclockwise (the Syrian bowl),

Fig. 6. Ceramic bowl from Syria, twelfth-thirteenth century. Ashmolean Museum, Oxford.

Fig. 7. Ceramic bowl from Iran, second half of the twelfth century. From the collection of Sir Alan Barlow.

Fig. 8. Sgraffito patterning of ceramic bowl from Nishapur, ninth century. The Metropolitan Museum of Art, New York.

but the pattern is closely similar. In both, an outlined white band separates this inner border from the horizontal rim; even the dimensions of the two vessels are similar.

The cusped field within a scalloped border of pendent semicircles also appears in an Iranian bowl of the second half of the twelfth century, where the pattern is cut into black slip applied over white, with forked sprigs in the semicircle (fig. 7).[19] A Byzantine rim fragment excavated in Corinth and classified as imitation lusterware seems to confirm the motif's derivation from Iran or Syria, where potters in specialized centers developed the luster technique to imitate metal.[20]

Another type of pattern that changes in Byzantine hands but cannot have originated there came ultimately from further east. It is a format in which the inside of the vessel is divided, like the cup of a flower, into lobed or pointed petal-like segments. Two examples from Serres that seem to develop this idea in separate ways are catalogue numbers 5 and 20. The triangular spandrels under the rims of these two bowls, between the lobes, contain individual sprigs or tendrils that function in the same way as the more elaborate sprigs of number 7; the sprigs indicate a directional rotation, counterclockwise this time. They are touched with color, while the lobes or points between them are left white. White petal-shaped fields already schematized in new ways, but more closely patterned after the flower form of Chinese lobed designs, are found painted in pottery bowls from Iran and Syria, beginning several centuries earlier than the period of the Serres pottery under discussion.[21]

A quirk in the delineation of the lobes in catalogue number 20—the cutting off of their curved tops by the border under the rim—ties the design to models that are not Chinese. Petal-like fields divided by decorated spandrels are inscribed on the walls inside a sgraffito bowl from ninth-century Nishapur; they are not rounded at the top but cropped at the rim (fig. 8).[22] Straight bands or borders chop off the arcs of a circle on the side of a painted fourteenth-century jug from Jazira that in other respects closely parallels an elaborate metal one.[23] In much the same way, at Serres the circular frames of the palmettes or leaves around the center of catalogue number 8 are lopped at top and bottom by the bordering bands.

MODELS IN METALWARE

Metalwork is presumed to be the ultimate model for sgraffito decoration. A Persian encyclopedia written for a Turkish dignitary in Syria advises him against gold and silver tableware because it drives the poor to despair, "when they cannot even get earthenware."[24] All glazed pottery, and all slip-decorated ware therefore, is one level of

luxury above the simplest tableware. It is likely that the more costly metalwares, like pottery, also traveled, although fewer of them survive. Richard Ettinghausen plausibly proposes that engraved brass vessels, rather than silver, provided the immediate models for patterns in sgraffito pottery.[25] But at each social level below the top, the highest luxury in tableware is to emulate the one above, adapting the more expensive effects of models in unattainable materials enjoyed by the wealthy. If the potters working in sgraffito technique copied their designs from accessible brass bowls, the brass bowls, in their turn, must have copied silver ones into more vernacular expression. Ironically, it is the pottery, cheapest of all, that now tells the tale most fully, since it was of no value for melting down, and remains unperishing, even if broken, in the earth.

Some Iranian sgraffito bowls are clear imitations of metalwork. One example of such a bowl displays many features that reappear in Serres pottery (fig. 9).[26] They include aspects of its shape, the ring base and the rounded lip, and also elements of its interior organization in concentric circles with a central medallion surrounded by a plain uncolored and undecorated ring, and enclosed by a broad band filled with linked, repeated units (compare catalogue nos. 8, 9, 11, 14-16). The comparisons extend to the scoring of the surface in selected areas with hatched lines of varying direction, to provide textural and tonal contrasts imitating those of punched, chased, or inlaid metalwork (compare nos. 5, 7-9, 14, 23). Further details of vocabulary or principles of syntax recognizable at Serres also appear here and in other examples from the Islamic world. There is a rhythm of centrifugal alternation punctuated by the radial direction of the largest encircling units, and the separation of each area from the next by a pair of circular lines. There are triangular spandrels below the rim, between the linked units, with a repeated foliate figure filling each spandrel. There are individual motifs, such as the guilloche, or the dot surrounded by a circle to form an eye for the creature in the medallion. Here the creature is a hare; on the Serres piece that is catalogue number 1 it is a bird, which has additional markings behind the eye.

Some of these same organizational features occur, in different forms, on two metal vessels. First is an elaborate plate from Damascus, of beaten and engraved copper inlaid with silver.[27] Like many luxurious pieces of metalwork, it has an inscription that helps us to date it closely: 1239-49. Its central medallion, like several at Serres, is not pictorial but is filled with a pattern revolving outward toward concentric rings. The linked units of the broad band in the well of the vessel create upper spandrels that are filled with threadlike ornament seen against dark interstices. This optical contrast is simplified in the Serres sgraffito ware, when wiry plants appear in the hatched spandrels. Even the copper plate's convex roll border with the inscription

Fig. 9. Ceramic bowl from Iran, tenth-eleventh century. Louvre, Paris.

15

Fig. 10. Bronze bowl, analysis of design inlaid with silver, from northern Syria or Jazira province, thirteenth century. Ashmolean Museum, Oxford.

finds a specific visual parallel on the rim of a Serres plate, catalogue number 1. In the potter's version there is no writing. The tall verticals of the calligraphic script have become simple parallel strokes, whose curve seems to imitate on the flat rim the curved profile of the metal molding. On the metal plate, punctuating the inscription at regular intervals, are circular disks with simple rosettes in their centers; on the pottery plate they have become buttonlike circles with central dots.

The second example, a thirteenth-century bowl with silver inlaid into bronze, from northern Syria or Jazira province, shows how a design of Kufic lettering has already been reduced to a border of purely decorative parallel strokes interspersed at regular intervals by medallions (fig. 10).[28] Other details on this bowl reflected in the Serres pottery include the plain band around the central medallion and the cusping, as on catalogue number 7, like a many-pointed star with curved sides, which we have already seen on Iranian and Syrian pottery bowls. The plain white field of the sgraffito ware interprets the bright sheen of the undecorated metal field.

PARALLELS FROM TANG CHINA

Lead-glazed earthenware plates and bowls imitating precious metalwork with a pattern of deeply grooved lines were being produced in Tang China (618-908 A.D.) while Byzantium suffered through the destruction of religious images during the Iconoclastic controversy. The Chinese vessels, on which applications of color, coordinated with the linear pattern, stand out against a white ground, were made for use by the nobility as tomb offerings.[29] They were not, as far as we know, widely if ever exported. Yet in some respects both their technology and their appearance parallel later sgraffito ware from the Middle East and from Byzantium, which makes their dependence on luxury items in other media an interesting case study.

There were two apparent motivations for the Chinese potters' grooved-line decoration. The first was aesthetic: they wanted to copy, rather than bury, tooled silver and gold. The second was practical, the wish to keep the colors inside their outlines by holding the glaze within the confines of each compartment in the pattern, and they succeeded by applying these patterns to flat surfaces where the lead glaze, when it melted, would not make the colors run downhill. Some Tang versions of centralized pattern-types, which were rendered in simpler forms on the pottery plates and bowls, may be seen on incised, chased, and repoussé vessels of silver and gold. A silver platter, the outside of a gold bowl, and the cover of a gold box all present concentric schemes with radiating, centrifugal elements and petal-shaped lobes in a ring.[30] The central unit of the platter is a plain,

16

undecorated band, cusped like that of a Serres piece, catalogue number 7. The same cusped band underlies a ring of linked, repeating radial units in one of the common Tang patterns for a pottery dish (fig. 11).[31]

A detail of production suggests a distant link between the Tang glazed pottery dishes and the work of potters further west. For large-scale production of glazed wares, it is expedient to stack the vessels one above the other in the kiln; but they need to be separated to keep the glaze from fusing them together. To this end, the Tang funerary dishes were provided with three unglazed feet, which served the same function as the tripod stilts later used by Byzantine potters, although not yet by those who produced the Serres wares.[32]

Fig. 11. Three-legged dish, from China, Tang period. Ashmolean Museum, Oxford.

COLOR AND ITS PRECEDENTS

So far, the discussion of design and its comparisons has centered on the incised elements of the Serres pottery. Color is just as important. The colors added to the pottery, without great expense, make a unique contribution in their counterplay with the incised design. Through color and tone Byzantine potters gave to sgraffito pottery qualities that go beyond the contrasts possible in metalwork. And the history of the colors in their use on Byzantine sgraffito ware again takes us back to Tang China. Tang pottery is not best known for the grooved funerary ware, just described, where the color is held confined in a linear framework. Rather, it is famous for splash ware in three colors of glaze, with drips of green or brown enlivening a creamy white surface. For visual excitement, Tang three-color ware far exceeds the green-glazed pottery of the early Byzantine and Roman tradition. This three-color ware has such a strong chromatic appeal that it was copied by potters in eighteenth-century England. At least one Persian pottery group shares the containment of the Chinese grooved and colored dishes, but many medieval potters from Iran westward developed the aesthetic effect of unconfined color on sgraffito ware.[33] Excavations at Nishapur have uncovered many early lead-glazed examples, and others are found at Ctesiphon and Samarra (the Abbasid capital founded in 836). Although the relationship between these wares and those of Tang China is not yet clearly understood, it is at Samarra that the earliest datable wares with incised decoration under the unconfined color appear.[34] The first criterion for comparing the color effects of Byzantine sgraffito ware with earlier pottery from the East is the choice of white slip as a background for the subsequently applied color. Whiteness of surface, where white clay was unavailable, as in Iraq, could be achieved instead by using tin glaze, which may sometimes approximate the appearance of sgraffito ware by sporting running splashes of green in combination with hatched and centrifugal linear drawing radiating from the center in the more easily controlled cobalt blue.[35]

17

In colored sgraffito ware the relationship between the color distribution and the incised design is almost infinitely variable, and quite different from the gilding or inlay or other coloristic effects of metalwork. Glazed pottery may be cheap, but it makes a unique aesthetic contribution through its color. At one extreme, as on a Nishapur bowl in the Metropolitan Museum of Art with floral units cut into the slip, the sgraffito work (illustrated in fig. 8) organizes the surface in a rhythm totally at odds with the dripped radial spokes of color overriding them.[36] At the other extreme is the full convergence of color and outline, as on the flat Tang plates where the color is held between grooves. Most of the Serres pottery follows a third direction, creating its own visual excitement in percussive color, applied in big, free strokes over a controlled melodic pattern of engraved lines. This structural use of color in the overall design exemplifies the Byzantine potter's skill in adapting existing models in fresh and spontaneous ways. The cut ground showing dark around the tooled slip in the so-called champlevé technique gives a tonal contrast similar to the silversmith's use of a darkening substance called niello, in combination with engraved work. The Serres potters employed their green and yellow-brown not so much for tonal contrast as for bringing the incised details into a larger focus of rhythmic motion. In part, as we have seen, the liveliness depends on the physical properties of color as it runs and spreads in the firing, becoming one in flux with the glaze so that it cannot easily be contained within tight linear boundaries.

This given expectation comes with the potter's inherited technology, as seen in the running and spreading colored glazes from Tang China and in the Iranian chromatic play with similar effects. But the Serres potters took advantage of it in their own constructive ways. The role of the colors on catalogue number 7 (color plate II) is especially spectacular. A yellow dash across the central disk makes it look like a metal surface reflecting moving light. Yellow touches this central disk at peripheral points. The same yellow outlines the rotation of the five curved arms of the star, and sets the enclosing pentagon in motion with it. The yellow bands on the rim spin it in the same direction, and the carefully controlled yellow border of the cusped white star-field diffuses the spin into radiation. Between these leading yellow gestures, the green steps in like a partner in a dance, to complete the rhythm. On the Serres pottery the colors consistently exploit this possibility for rhythmic interplay. No wonder the Italians who imported, copied, and eventually moved into a new idiom from these wares enjoyed their creative freedom besides learning from their technology. The colors of the pottery from Serres define an aesthetic of exuberance that the incised work alone could not fully communicate, a quality that sets the pointed zigzagging petals of a Serres bowl, catalogue number 5, a world away from their sedate and formal Eastern models.

CONCLUSION

Color and engraved decoration together in the hands of the Serres potters drew upon well-established Byzantine traditions with strong links to tableware from further east. At the same time the vocabulary of birds, of vines and flowers, circles

and stars speaks a welcome message with echoes deep in folk culture through Byzantine history. On many of these plates and bowls the owner would have recognized tokens of prosperity, and propitious, apotropaic, or even magical signs that made such tableware an even more joyful possession. The mystique of precious plates or dishes from ancient times and foreign places is a documented aspect of cultural expectation: excavations of medieval Corinth found incised Persian ceramic vessels in the best-endowed homes of the late eleventh to the late twelfth century.[37] People seem to have treasured their best sgraffito ware as heirlooms, and to have buried it with their dead.[38] In the Crimean port of Cherson a house that burned down in the fourteenth century was discovered to have preserved the remains of a large sgraffito pottery plate with a Byzantine St. George and the dragon, perhaps up to two hundred years old when it was lost with the house, broken and mended and lovingly preserved by the people who lived there, trusting themselves to the saint's protection until that time.[39]

NOTES

1. R. Byron, *The Byzantine Achievement* (New York, 1929), 211.

2. D. M. Nicol, *Church and Society in the Last Centuries of Byzantium* (New York, 1979), 1.

3. B. Berenson, "Decline and Recovery in the Figure Arts," in *Studies in Art and Literature for Belle Da Costa Greene*, ed. D. Miner (Princeton, 1954), 27.

4. J. Raby and M. Vickers, "Puritanism and Positivism," in *Pots and Pans*, ed. M. Vickers (Oxford, 1986), 217-23.

5. J. D. Mansi, *Sacrorum Conciliorum nova et amplissima collectio*, vol. 13 (Venice, 1767), 252; trans. C. Mango, *The Art of the Byzantine Empire* (Englewood Cliffs, N.J., 1972), 172.

6. M. Vickers, O. Impey, and J. Allan, *From Silver to Ceramic* (Oxford, 1986), pl. 26.

7. J. A. Cramer, ed., *Anecdota graeca e codd. manuscriptis biliothecae regiae parisiensis* (Oxford, 1841; rpr. Hildesheim, 1967), vol. 4, 276-78; trans. in H. Maguire, "A Description of the Aretai Palace and Its Garden," *Journal of Garden History* 10 (1990): 209-13.

8. J. Rawson, *Chinese Ornament: The Lotus and the Dragon* (London, 1984), 90, 99-109, figs. 69, 76, 82, 85, 112; A. Goldschmidt and K. Weitzmann, *Die byzantinischen Elfenbeinskulpturen des X.-XIII. Jahrhunderts*, vol. 1 (Berlin, 1930), 63, no. 122, pl. LXXd.

9. *Geoponika*, 10:9; ed. H. Beckh (Leipzig, 1895), 272-73. See also L. Brubaker and A. Littlewood, "Byzantine Gardens," in *Antike Garten im Mittelmeerraum*, ed. M. Carroll-Spillecke (Mainz, forthcoming).

10. *Michel Italikos. Lettres et discours*, ed. P. Gautier (Paris, 1972), 157.

11. *Oxford Dictionary of Byzantium*, vol. 2 (Oxford, 1991), 1418.

12. C. Morgan, *Corinth, XI, The Byzantine Pottery* (Cambridge, Mass., 1942), 110-14, 170-71.

13. J. Lefort, "Séminaire de J. Lefort à l'E.P.H.E., Anthroponymie et société villageoise (Xe-XIVe siècle)," *Hommes et richesses dans l'empire byzantin*, vol. 2, ed. V. Kravari, J. Lefort, and C. Morrisson (Paris, 1991), 225-38, esp. 237.

14. *De diversis artibus*, 16, ed. and trans. C. R. Dodwell (London, 1961), 47.

15. E. Ioannidaki-Dostoglou, "Les vases de l'épave byzantine de Pélagonnèse-Halonnèse," in *Recherches sur la céramique byzantine,* ed. V. Déroche and J.-M. Spieser, Bulletin de Correspondance Hellénique, Suppl. XVIII (Athens, 1989), 157-71.

16. L. Lazzarini and S. Calogero, "Early Local and Imported Byzantine Sgraffito Ware in Venice: A Characterization and Provenance Study," in *Archaeometry: Proceedings of the 25th International Symposium,* ed. Y. Maniatis (Amsterdam, 1989), 571-84.

17. J. W. Allan, *Islamic Ceramics* (Ashmolean Museum, Oxford, 1991), no. 18.

18. Ibid., no. 25; pl. 43a.

19. A. Lane, *Early Islamic Pottery* (London, 1947), pl. 48.

20. Morgan, *Corinth,* no. 617, pl. 26e.

21. *Sept mille ans d'art en Iran* (exh. cat., Petit Palais, Paris, 1962), no. 946, pl. 105 (an example from Nishapur); Allan, *Islamic Ceramics,* nos. 6 and 25; J. Rawson, *Chinese Ornament: The Lotus and the Dragon* (London, 1984), 122-25 and figs. 102-3.

22. Lane, *Early Islamic Pottery,* 12, pl. 6B.

23. J. W. Allan "The Survival of Precious and Base Metal Objects from the Medieval Islamic World," in *Pots and Pans,* ed. Vickers, fig. 8.

24. Assadullah Souren Melikian-Chirvani, "Silver in Islamic Iran: The Evidence from Literature and Epigraphy," in *Pots and Pans,* ed. Vickers, 102-3.

25. R. Ettinghausen,"The 'Wade Cup' in the Cleveland Museum of Art, Its Origin and Decorations," *Ars Orientalis* 2 (1957): 341-42.

26. *Arts de l'Islam des origines à 1700* (exh. cat., Orangerie des Tuileries, Paris, 1971), no. 22.

27. Ibid., no. 153. The plate is now in Paris.

28. Vickers et al., *From Silver to Ceramic,* pl. 65.

29. J. Rawson, "Tombs or Hoards: The Survival of Chinese Silver of the Tang and Sung Periods, Seventh to Thirteenth Centuries A.D.," in *Pots and Pans,* ed. Vickers, 37 and fig. 7; W. Watson, "Precious Metal—Its Influence on Tang Earthenware," ibid., 161-77.

30. C. W. Kelley, *Tang Dynasty (AD 618-907) Chinese Gold and Silver in American Collections* (Dayton, Ohio, 1984), no. 2; Watson, "Precious Metal," 164 and fig. 4; Vickers et al., *From Silver to Ceramic,* pl. 36.

31. Vickers et al., *From Silver to Ceramic,* pl. 37; Watson, "Precious Metal," fig. 7; *Chinese Ceramics: Art and Technology* (exh. cat., High Museum of Art, Atlanta, 1985), no. 60.

32. H. Kim, "China's Earliest Datable White Stonewares from the Tomb of King Muryong (d. A.D. 523); Paekche, Korea," *Oriental Art* 37 (1991): 20.

33. Lane, *Early Islamic Pottery,* 25.

34. Watson, "Precious Metal," 170-71.

35. Allan, *Islamic Ceramics,* no. 2.

36. M. S. Dimand, *A Handbook of Muhammadan Art* (New York, 1947), fig. 95.

37. Morgan, *Corinth,* 169, fig. 147.

38. A. I. Dikigoropoulos and A. H. S. Megaw, "Early Glazed Pottery from Polis," *Report of the Department of Antiquities, Cyprus 1940-48* (Nicosia, 1957), 77; A. Vavylopoulou-Charitonidou, "Céramique d'offrande trouvée dans des tombes byzantines tardives de l'hippodrome de Thessalonique," in *Recherches sur la céramique byzantine,* ed. Déroche and Spieser, tomb XI, bowl no. 101, 216, fig. 14.

39. A. H. S. Megaw, "Zeuxippus Ware Again," in *Recherches sur la céramique byzantine,* ed. Déroche and Spieser, 259, fig. 1.

2

SERRES: A GLAZED-POTTERY PRODUCTION CENTER DURING THE LATE BYZANTINE PERIOD

Demetra Papanikola-Bakirtzis

Pottery remains one of the most neglected branches of Byzantine art. Glazed tableware—little known and seldom displayed in museums—has certainly not received the attention it deserves. The situation seemed more promising in 1930 when David Talbot Rice published his book *Byzantine Glazed Pottery,* in which he presented what was then known about the subject and classified the pottery into groups.[1] Twelve years later C. Morgan published the glazed pottery from the excavations at Corinth and proposed an improved and more consistent classification as well as a chronology for the different groups, based on the excavation data.[2] A further advance was made by R. Stevenson in his publication of the glazed pottery from the excavations in the Great Palace at Constantinople. Thanks to methodical stratigraphy, he was able to produce a better chronology for the various groups of Byzantine glazed wares, especially the pottery from Constantinople.[3]

Despite these developments, the study of Byzantine pottery made little headway in the years that followed. Among the exceptions were the pioneering articles by A. H. S. Megaw, which centered on isolating groups of pottery from the same workshop, and through which the splendid vases of the Zeuxippos ware and the Incised Sgraffito plates of the Aegean ware became known.[4]

In recent years, however, matters appear to have changed in the study of Byzantine pottery. The sherds from Byzantine excavations not only attract attention and interest and are carefully collected but reach the stage of publication either in excavation reports or in separate articles. In 1987, in Athens, the French Archaeological School organized the first specialized conference on Byzantine pottery.[5] And the discovery of two shipwrecks with cargoes of glazed pottery, one at Alonysos in the Sporades and the other between Rhodes and Kastelorizo in the Dodecanese, yielded important information about the trade in clayware during the Byzantine period.[6]

Research in this field now concentrates on locating workshops and recording the

characteristics of their products. Interest also centers on the related problem of the technology of the Byzantine potteries and their installations. Much light has been shed on these issues by the information yielded by the Byzantine city of Serres in northern Greece.

Byzantine glazed pottery is a low-fired earthenware. Investigation of its different stages of production has been aided by archaeological finds and observations and also by the information afforded by examining the techniques and working methods employed in the traditional workshops existing today, which because of their conservative technological evolution are not far removed from the way in which Byzantine potters worked. A knowledge of these production methods is essential to the study of Byzantine pottery.

Fig. 12. Wooden mallet for pulverizing earth.

THE TECHNIQUES OF PRODUCTION OF BYZANTINE GLAZED POTTERY

Preparation of the Clay

The earth obtained by the potter for making pots is not pure but full of unwanted impurities—stones, grit, and sand. The first step is to pound the earth in order to pulverize it. Modern traditional potters use wooden mallets, and their Byzantine forebears must have done the same thing (fig. 12). The pulverized earth is sieved to remove coarse inclusions such as stones and roots. To further purify it the sieved earth is mixed with water in special levigation tanks dug in the ground. During the mixing of the earth and water the remaining heavy impurities are allowed to sink to the bottom of the tanks and the lighter organic matter floats to the surface. After the surplus water has been drained off, the clean clay residue is ready for wedging; this removes the air pockets in the clay and renders it compact and suitable for throwing on the wheel, for Byzantine glazed pottery was all wheel-made.

Throwing

No potter's wheel has yet been found in excavations of the Byzantine period, which is hardly surprising since potter's wheels may have been made of wood. However, the thin walls of the glazed vases and their shapes in general presuppose

Fig. 13. Traditional workshop with a foot-operated wheel on the island of Thassos.

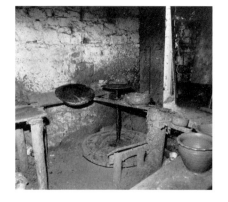

the fast speed of a foot-operated wheel. The Byzantine wheel, at least the one used for fine tableware, must have resembled the kick-wheel used in the traditional workshops in the lands of the eastern Mediterranean (fig. 13). This consists of a wheel-head on which the vessels are thrown and a larger flywheel below it. The two disks are connected by an axle, and the wheel-head revolves as the potter kicks the flywheel with his foot. The potter places the clay on the wheel, lump by lump, and shapes the pot. This is the most creative moment in the making of a clay vessel. With the aid of the revolving wheel the potter becomes a creator, giving form and life to the amorphous mass of clay. The finished pot is carefully removed from the wheel and set in a suitable place to dry. Care must be taken to ensure that the pot dries evenly and that the

clay does not crack. When the pot is dry enough to hold its shape it is ready for decorating.

Decoration: The Sgraffito Technique

The preeminent, most widespread and enduring decorative technique used on Byzantine pottery was that of incising or engraving on pots made from red clay. The potter first applied a white slip to the surface intended for decoration. On open vessels this surface was as a rule the inside and on closed vessels the outside. Into this light surface, while the slip was still fresh, the potter cut the design, using a sharp point for the purpose, usually a piece of suitably shaped and smoothed cane. The incision allows the bare red clay under the slip to show through, so that the engraved lines of the decoration show up dark against the light ground of the slip. This technique calls for skill, speed, and decisiveness. Every incision made on the fresh surface is irreversible; mistakes cannot be rectified.

The width of the engraved line is what largely gives the decoration its character and is the feature that distinguishes the different classifications of Byzantine glazed pottery. In the Fine Point Sgraffito group, as the name indicates, the line is particularly thin; the motifs are delicately rendered, with careful detail. They chiefly comprise bands with tangential or running spirals encircling the interiors of open vessels, and at their centers, medallions with palmettes. There are also figural representations with animals, birds, dragons, and people (fig. 14). Chronologically the Fine Point Sgraffito technique covers the period from the eleventh to the twelfth century.

After the middle of the twelfth century the incised line becomes broader. At first, broad incision is used to emphasize particular details or to render the main lines of the decorative themes. A little later it is used to render the whole subject. Subjects executed by broad incision include simple linear motifs, birds with characteristically long beaks and tails, and also human figures, chiefly representations of warriors

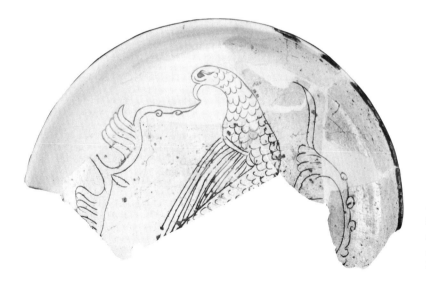

Fig. 14. Vessel decorated with a bird. Fine-Point Sgraffito. From Synaxis-Maroneia in Thrace, mid-twelfth century.

23

with spears and shields. These warriors are taken to be depictions of heroes of the border folksongs (fig. 15), ballads of medieval Hellenism that celebrate the exploits and amorous adventures of the guardians of the eastern borders of the Byzantine empire.[7]

Another development of the twelfth-century sgraffito technique was the removal of the slip coating around the representations in such a way as to make the decoration appear to be in low relief on the dark-colored bare clay. To describe this technique the French term *champlevé* is appropriate because it conveys precisely its main characteristic, the excision of the background. This technique was used to create charming images of rabbits and animal groups as well as human figures such as dancers and musicians (refer back to fig. 4).

Color

By the end of the twelfth century and the beginning of the thirteenth, the sgraffito monochrome appears to have lost its popularity in the face of a growing demand for polychromy. Brushstrokes with yellow-brown color begin to appear, varying the incised decoration on the Zeuxippos ware. Soon afterward green brushstrokes follow, giving colorful variety to the vases of Aegean ware, which in their technique of decoration belong to the Incised Sgraffito category. The practice of enhancing the sgraffito design on the various Incised Sgraffito wares with fugitive yellow-brown and green tints should be distinguished from the way the color is used on some twelfth-century vases, referred to as Painted Sgraffito ware. On these vases green and dark-brown colors are used to paint independent motifs, not overlying the sgraffito designs, but placed beside them.

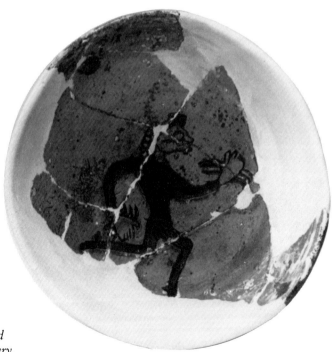

Fig. 15. Vessel with engraved sgraffito decoration. From Thessaloniki, second half of twelfth century.

24

In a short time the use of color on Incised Sgraffito ware became predominant and played a decisive part in the decorative result. Although initially green and yellow-brown were used on separate pieces, they quickly made their appearance together on the same vase. The green and yellow-brown colors are made from copper and iron oxides respectively. The colors are usually applied independently and alternately with each other and do not follow the engraved subject except in a general way. The colors appear to have had a vitreous composition with a consequent tendency to spread and impregnate the covering layer of glaze.

Glaze

The Byzantine potters used a lead glaze on their vases. This was the principal type of glaze in the Middle Ages. Until quite recently, if not up to the present day, the traditional potters of Greece and the Middle East continued to use lead glaze. Its distinctive characteristics made it popular over such a long period of time. Its principal advantage is the fact that it produces shine and transparency at low firing temperatures and is easily colored with the oxides of other metals such as copper and iron.

Kiln-Firing Process

The remains of pottery kilns of the Byzantine and post-Byzantine periods have been found in Greece, the Balkans, the Crimean port of Cherson, and Cyprus.[8] They show that the updraft kiln was the principal type used in the Byzantine potteries. A fire was lit in the lower compartment, the fire chamber, and was fed with wood from the fire pit, which was attached to one side of the fire chamber. The latter was generally sunk into the ground, so that loss of heat was prevented and the lower load-bearing section of the kiln wall was reinforced by the walls of the pit. One or more pillars supported the roof of the fire chamber, which was also the floor of the upper chamber. This upper compartment was the main chamber of the kiln, where the pots were stacked for firing. Its floor was perforated with many holes through which the heat from the fire in the lower chamber reached the stacked pots.

In the remains of the kilns that have come to light in various excavations only the lower part has survived, and we therefore have no details about the upper chamber. We do not know, for example, if it had a permanent domed roof or was open, to be closed by a temporary cap for the duration of the firing. Both types of kiln have continued in existence in Greece and the countries of the eastern Mediterranean until today. As a rule, however, kilns with temporary roofs are used for coarse, unglazed pottery, and the permanently roofed ones for fine, glazed tableware.

The firing is certainly the most difficult stage in the making of pottery, and it is principally responsible for the success or failure of the finished product. The stacking of the pots in the kiln calls for skill and experience and was consequently performed by the head of the workshop. A good firing has two different and conflicting aims. The main concern is that the pots should receive the same heat on all sides because there is a great danger of breaking or warping if the fire strikes them unevenly. The problem is accentuated in the case of glazed pottery, wherein glazed surfaces of adjacent pots can adhere to one another. This occurs as the

temperature increases and the glaze liquefies and adheres irreversibly to whatever comes in contact with it. The second aim is to make efficient use of the small space in the kiln by stacking as many pots in it as possible.

The solution to this problem was found when the Byzantine potters adopted the use of tripod stilts inside the kilns. The tripod stilt is a small clay device with three legs ending in pointed feet (fig. 16). The insertion of these simple but effective tripod stilts made it possible to stack the pots vertically one on top of the other without fear of the glazed surfaces sticking to each other. In addition, this new method of stacking facilitated the free circulation of heated air from the fire chamber and allowed the full utilization of the space within the kiln. The drops of glaze often found on the rims of Byzantine vases and the absence of accumulated glaze in the bottoms show that the vases were stacked upside-down inside the kiln (fig. 17). Taking away the tripod stilts after the firing removed the glaze at the three points where it had adhered to the feet of the stilt, leaving three small spots of bare clay on the bottom of the vase. Although all tripod stilts served the same purpose and were apparently similar, they were not all made in the same manner: they were made by hand, on the wheel, or in molds.[9]

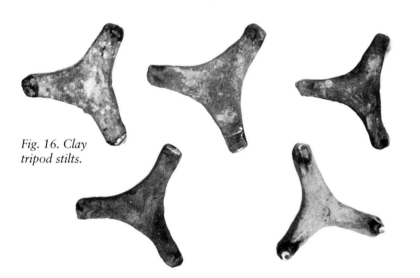

Fig. 16. Clay tripod stilts.

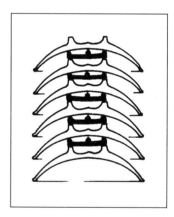

Fig. 17. Vessels stacked with tripod stilts in between.

It is generally agreed that the tripod stilt was imported into Byzantium from the Islamic world, where its use dates back to the ninth century. The Islamic potters in turn appear to have taken the method from the great teacher of Islamic pottery, China. The first indication of Byzantine use of the tripod stilt is found on vases of Zeuxippos ware and is dated to around 1200.[10] The adoption of the tripod stilt determined the future development of Byzantine pottery, because it made possible mass production and led to the overthrow of the hitherto prevailing economy in the Byzantine potteries.

A study of the discarded pottery from the Byzantine workshops, including wasters—pots that were damaged before the completion of the potting process—

indicates that Byzantine glazed wares underwent at least two firings. The first one, the biscuit firing, took place after the pot had been decorated and had reached the leather-hard stage. After the first firing, the vessel was given a coating of glaze and put into the kiln a second time for the glaze firing, in which the glaze vitrified and became transparent and shiny. As will be seen below, some colored wares were given three firings. In this way the vase acquired a glassy skin that was impermeable yet at the same time showed off the decoration.

Serres Ware

Earlier excavations in the vicinity of the Old Metropolis of Ayioi Theodoroi and recent excavations in building lots in the town of Serres have brought to light a large amount of pottery. The material includes virtually every type of Byzantine ware, ranging from the early, rare Polychrome ware, the delicately tooled Fine Point Sgraffito, and the striking Champlevé of the Middle Byzantine period to the plainest, undecorated types of the post-Byzantine years.

One could hardly fail to notice, however, the large quantity of pottery belonging to the Late Byzantine period, in particular the vases with Colored Sgraffito decoration embellished by yellow-brown and green. The pots of this group possess common features in terms of clay, shape, and decorative motifs and give the same impression of lavish color.

A detailed inventory and classification of this material has enabled us to present a quite comprehensive picture of this class of pottery, which we believe was produced in the workshops of Serres.[11]

Clay

The clay is red, rather coarse and micaceous. It is usually well fired, and sometimes indeed overfired, which gives it a greyish hue.

Shape

The overwhelming majority of the pots are open shapes, mainly bowls, with a lesser number of dishes and plates. The bowls have a hemispherical body terminating in a simple lip (catalogue nos. 4, 10, 23) or in a vertical concave rim above a carination (catalogue nos. 11-14, 16, 20, 22). The dishes have a shallow body and high rim that forms an obtuse angle with the body (catalogue nos. 2, 3). The plates have a relatively flat body with a vertical wall and narrow horizontal rim (catalogue nos. 1, 7, 8). There are a small number of sherds from closed shapes such as jugs (catalogue nos. 24, 25).

The bases are low ring feet or are slightly raised, generally with some flare. A noteworthy characteristic is the way the foot is partly hollowed out of the thickness of the bottom, sometimes forming a small nipple in the center. This common feature also tells us something about the way the vases in this group were made. It shows that their bases were what potters call "trimmed bases"; in other words, they were made in a second stage, during which the pot was put on the wheel again when it

was at the near leather-hard stage, upside down this time, in order to facilitate work on the outside. For this the potter used the wheel and a special implement, usually a piece of wood with a broad end, to finish off the external surface by removing the surplus clay around the ring and inside the foot.

There is a wide variety of shapes. The basic bowl, dish, and plate appear in many forms and sizes, showing that they were intended for a society that demanded an assortment of different tableware to go with its rich and varied diet.

Slip Decoration

The insides of the vases are coated with a slip, which is white, moderately fluid, and covers the interior and the rim; not infrequently it also extends over the exterior as well, where in most instances it is thinner. In other cases the slip is used to decorate the outside with simple or intersecting circles or dots (figs. 18 and 19).

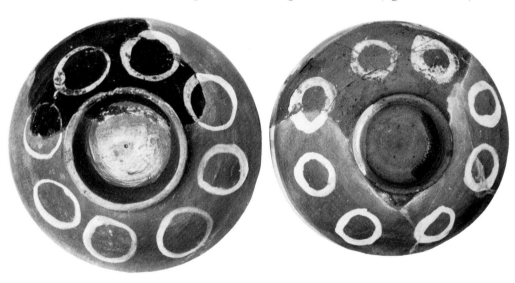

Figs. 18 and 19. Slip-painted decoration on the exterior surfaces of vessels from Serres.

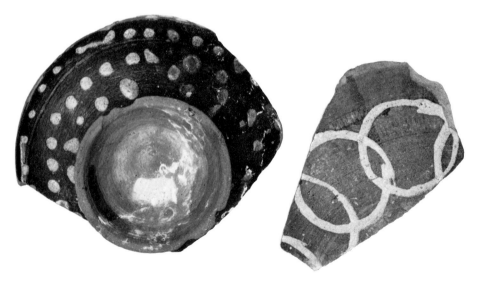

Sgraffito Decoration: Decorative Motifs

The Colored Sgraffito decoration of this pottery, which is embellished, as we have said, with yellow-brown and green colors, has characteristic features. The engraved lines are of medium thickness and the engraved decoration profuse. Individual motifs are often rendered in the champlevé technique or set on a hatched ground. The hatching is made with many fine parallel lines or a looped line producing a scale pattern.

The repertory of images is rich and diverse. A considerable number of vases depict birds, drawn with vigor and skill. They are either rendered in free style on the bottom of the vase or set in a medallion. Two types of bird appear. The first has a large body with long, powerful legs and relatively large wings; its plumage is rendered by parallel lines, groups of which run in different directions (catalogue nos. 1-4). The tail is long and twisted, and the neck is long and sturdy; the raised head pecks at a pointed tree or shoot. This type of bird is depicted in free style on the background and occupies the whole of the bottom of the vase.

The second kind of bird has a squat body with short legs; the surface of the body is left undecorated and only the wing has parallel horizontal lines or some spiral decoration (catalogue nos. 5 and 6). The birds of this type hold vegetation in their beaks and as a rule are set in a medallion that usually fills the center of the bottom of the vessel. On fragment number 6, however, the medallion with the bird is at the side of the vase. Among pieces showing birds in medallions, vase number 5 stands out. The way in which the subject is adapted to the circular field and the sure and steady line of the drawing are particularly admirable. The choice of the champlevé technique to show off the representation adds notably to the aesthetic effect created by this Byzantine vase.

The birds of this second type are related to those on the twelfth-century group of Painted Sgraffito ware, which differs however in the treatment of the colors. In this group the color—dark brown and green—is not used to accentuate the engraved decoration but to render, independently, spirals and running spirals.[12]

Although it is the birds that catch and impress the eye, the predominant themes in this group of vases from Serres are foliate. They are varied both in their form and in the way they are represented. The foliage is enclosed in a central medallion and arranged in borders or wide bands around it. In the medallion is usually inscribed a spiral sprig, a trefoil, or a palmette (catalogue nos. 11, 12, 15, 19, 20, 22, 23). Another sort of ornament used in the bottom is a star-shaped motif inscribed in a pentagon (catalogue nos. 7, 8, 10). The motifs in the medallion are made with medium-point incision or the champlevé technique. In the bands around the medallion the foliate motifs include tendrils encircling trefoils or palmettes, running spirals, and vinescrolls, as well as a variety of guilloche motifs (catalogue nos. 11-15, fig. 20). They are depicted on a hatched ground of tightly packed parallel lines or a scalelike pattern. On a number of vases, around the medallion and radiating out from it, there are stripes with spirals or shoots alternating with triangles or lozenges containing palmettelike trefoils (catalogue nos. 20, 21). Also around the medallion a row of pointed leaves may be depicted, giving the impression of a large rosette extending over the whole interior of the vase (catalogue nos. 18, 19).

Color

The first decoration, as we have seen, is made by incision, but color plays an equally important role in the final appearance of the pot. The colors used on the Serres vases are those well known on Byzantine pottery: iron oxide for the yellow-brown and copper oxide for the green. The colors are bright and intense. They are applied alternately with each other and generally follow the main lines of the engraved theme or composition, setting up contrasts or defining zones, with no attempt made to trace details or follow the inner outlines of the engraved subjects. An interesting fragment (catalogue no. 2) provides useful information about the composition and texture of the colors used on the Serres pots, and about how and at which stage in the production process they were applied. This fragment is decorated with engraving and also shows distinct brushstrokes of glossy yellow-brown and green color. We can see, however, that it was not given the final coat of glaze, and part of the surface was left bare, with only the engraved coating of the slip. This shows first that the Serres potter was accustomed to applying the color on the prefired vessel, and second that he proceeded to the second firing without applying the final coat of glaze. It must have been at this stage in the process that the pot from which this fragment came was broken or damaged in some way, before it received the final overall coat of glaze and was fired for the last time. This makes it clear that the Serres potters fired their vases three times altogether: the first time for the biscuit, the second for the color, and the third for the glaze. A vase found at Maroneia in Thrace (catalogue no. 23) embodies features typical of the Serres workshop. Its decoration, however, is enhanced only by yellow-brown color. Whether this vessel happens to be an exception and a fortuitous instance or whether we should regard it as a precursor of the Serres group of Colored Sgraffito vases with yellow-brown and green color remains a problem.

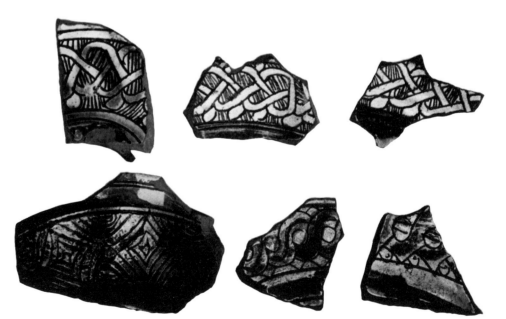

Fig. 20. Various guilloches from Serres pottery.

Glaze

The glaze used by Serres potters has a thin consistency and covers only the interior of the vase and the top of the rim with a clear coating. In rare cases it spreads over the exterior as well, as in catalogue numbers 6 and 14. The glaze is colorless, and in the few instances where it has a yellowish or greenish appearance, this is due to its having absorbed the tint from the glossy color used for the decoration. Vases numbers 6 and 14 form an exception: their exterior surfaces bear an actual yellow glaze. The glaze is usually of good quality but occasionally shows signs of flaking together with the slip.

The Location of the Workshop

The finding of a large number of sherds with common characteristics is always a good indication that these sherds are the products of the same workshop. It is also reasonable to assume that the location of the workshop must have a connection with the place where the sherds were found. This is exactly the case with the pottery from Serres described above. The large concentration of vases with similar characteristics in terms of clay, shape, and decorative motifs implies that the production of this pottery must be connected with the Byzantine town of Serres.

This suggestion is strongly supported by the finding of half-finished vases with the same characteristics: catalogue numbers 2, 9, 10, and 16. Numbers 9 and 10 are biscuit-fired wasters; they have engraved decoration and are without color or glaze.[13] On fragment number 2, as has been seen above, the decoration has been further enhanced with brushstrokes of vitreous yellow-brown and green color; it is therefore one stage more advanced than the preceding examples. Vase number 16 was damaged in the last stage of production, since it had already received its coat of glaze and been put in the kiln for the final glaze firing. In addition to these unfinished examples, a recent rescue excavation at Serres produced four more biscuit-fired wasters belonging to the same type of vase.[14] They had all been spoiled and were rendered unusable before their final completion; they were rejects from the pottery-making process, and we may therefore assume that the general area where they were found was also where they were made.

Further evidence for the existence of pottery workshops at Serres came from the discovery of some objects connected with stacking the kiln and the firing process. These are clay rods some 3.5 cm in diameter, which were fixed in rows of close-set holes around the walls of the kiln so as to form a kind of shelving on which the vases stood during the firing (fig. 21). They were also used to suspend closed vases, as shown in figure 22. Similar objects are known from excavations of kilns for Islamic pottery,[15] but this is the first time that they have been noted in the Byzantine world. Clay objects of circular section, but smaller in diameter than the rods and shaped like an S, have also been found; these must have served to suspend small articles in the kiln, or else were placed between the glazed vases during the firing to prevent the glazed surfaces from sticking to each other. Such objects have been found in the excavations of Byzantine Corinth.[16]

The discovery of these objects supplies valuable information about the equipment of the kilns in which the Serres vases were fired. The pots bear no marks of the

tripod stilts that enabled vases to be stacked vertically in columns, leading us to conclude that such stilts were not used for this ware. We must imagine the firing being carried out using the clay rods, which formed subsidiary shelves inside the kiln, and the clay S-shaped objects, which helped prevent contiguous vases from sticking to each other.

Distribution

Having formed an adequate picture of this kind of pottery, which evidence strongly suggests was made at Serres, and having recorded its features, archaeologists have made an attempt to identify vases outside the Serres region that could be assigned to the same group. Vases exactly like those of Serres have been found in

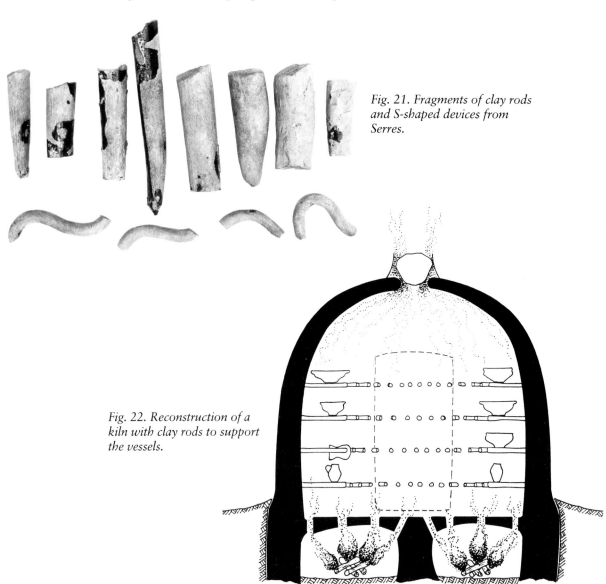

Fig. 21. Fragments of clay rods and S-shaped devices from Serres.

Fig. 22. Reconstruction of a kiln with clay rods to support the vessels.

excavations at nearby Melenikon.[17] Other sites where they have been discovered include Thessaloniki and Philippi (catalogue no. 22) in Macedonia; Maroneia (catalogue no. 23) and Mosynopolis (catalogue no. 12) in Thrace; Corinth; and in Byzantine Skoupi (Skopje) and Prilapos (Prilep).[18] A plate that can be linked without hesitation to the Serres vases was found embedded in a wall of a church in Molyvdoskepasti, in Epirus;[19] and a relatively small fragment of a vase with the characteristics of the Serres vases was found at Venice during the cleaning of the laguna[20] (fig. 23).

Chronology

Most of the pottery has come from old cleaning excavations without stratigraphy, and unfortunately the material from the more recent rescue excavations did not come from undisturbed strata. Efforts to date it, therefore, must rely on the material itself and the evidence it affords.

To begin with, this kind of decoration, which is engraved and embellished with yellow-brown and green colors, does not appear before the Late Byzantine period and becomes prevalent after the middle of the thirteenth century.[21] The decorative motifs fall within the known repertory of Byzantine pottery as it was formed during the Palaeologan period: palmettes, different kinds of guilloches, running spirals enhanced with turned-up trefoil or heart-shaped leaves, and depictions of birds. The motifs are distinguished by their great variety and an eclecticism in the manner of

Fig. 23. The distribution of Serres pottery.

their rendering. According to circumstance, use is also made of the champlevé technique with broad and narrow incision. Both these elements, namely the great diversity of motifs appearing in different variations, and the eclecticism of the manner of treatment, are characteristic of Palaeologan pottery.

Furthermore, the shapes of the vases are typical of the thirteenth century; the most common shape, the bowl with a vertical concave rim, is rarely found before then. It occurs among the evolved types of the Zeuxippos group and is predominant in Cypriot glazed pottery of the thirteenth century. Forms like that of the plate with a high flaring rim, which is more closely associated with the twelfth century, may be considered survivals in the thirteenth.

All of these factors suggest a date for the Serres vases in the thirteenth century, and more specifically in its second half. A thirteenth-century date also agrees with the dating of the pottery from the excavations at Melenikon,[22] which, as has been noted, should be assigned to the same group. It seems likely that this kind of pottery also survived into the fourteenth century; one of the two fragments from Corinth attributed to Serres was found in a late thirteenth or early fourteenth-century cesspit.[23] The cultural context of the city during that period will be presented in the next chapter.

NOTES

1. D. Talbot Rice, *Byzantine Glazed Pottery* (Oxford, 1930).

2. C. Morgan, *Corinth, XI, The Byzantine Pottery* (Cambridge, Mass., 1942).

3. R. B. K. Stevenson, "The Pottery, 1936-1937," *The Great Palace of the Byzantine Emperors,* vol. 1 (Oxford, 1947), 31-63.

4. A. H. S. Megaw, "Zeuxippus Ware," *Annual of the British School at Athens* 63 (1968): 67-88; idem, "An Early Thirteenth-Century Aegean Glazed Ware," in *Studies in Memory of David Talbot Rice,* ed. G. Robertson and G. Henderson (Edinburgh, 1975), 34-45.

5. The proceedings are published in *Recherches sur la céramique byzantine,* ed. V. Déroche and J.-M. Spieser, Bulletin de Correspondance Hellénique, Suppl. XVIII (Athens, 1989).

6. E. Ioannidaki-Dostoglou, "Les vases de l'épave byzantine de Pélagonnèse-Halonnèse," ibid., 157-71; M. Michaelidou and G. Philothéou, "Plats byzantins provenant d'une épave près de Castellorizo," ibid., 173-76; I. Loucas, "Les plats byzantins à glaçure inédits d'une collection privée de Bruxelles," ibid., 177-83.

7. J. Notopoulos, "Akritan Iconography on Byzantine Pottery," *Hesperia* 33 (1964): 108-33.

8. Corinth: Morgan, *Corinth,* 14-21. Didymoteichon-Pherrai: C. Bakirtzis, "Didymoteichon: un centre de céramique post-byzantine," *Balkan Studies* 21 (1980): 151-53. Varna: D. Dimitrov, "Rabotilnica za trapezna keramika vŭv Varna," *Bulletin de la Société Archéologique à Varna* 11 (1960): 111-17. Cherson: A. L. Iakobson, *Keramika i keramičheskoe proizvodstvo Srednevekovoj Tavriki* (Leningrad, 1979), 147-58, fig. 101. Cyprus: A. H. S. Megaw and R. E. Jones, "Byzantine and Allied Pottery: A Contribution by Chemical Analysis to Problems of Origin and Distribution," *Annual of the British School at Athens* 78 (1983): 239-40.

9. D. Papanikola-Bakirtzis, "The Tripod Stilts of Byzantine and Post-Byzantine Pottery" (in Greek), in *Ametos,* Volume in Honor of Professor Manolis Andronikos (Thessaloniki, 1986), 641-48.

10. Megaw, "Zeuxippus Ware," 69, 87.

11. We are not sure if one workshop was involved or several. A study of contemporary traditional pottery workshops suggests the latter, for single traditional pottery workshops are rarely encountered. As a general rule, a number of them, producing similar vessels, are found concentrated together within a wider locality.

12. Morgan, *Corinth,* 140-42.

13. For the opportunity to study these two wasters I am indebted to Mr. N. Zekos. He was responsible for the excavation that brought them to light.

14. *Archaeologikon Deltion* 39 B (1984): 284.

15. R. Naumann, "Brennöfen für Glasurkeramik," *Istanbuler Mitteilungen* 21 (1971): 175, pl. 56, 1, and figs. 7, 8.

16. Morgan, *Corinth,* 21-22, fig. 17, j-l.

17. B. Cvetkov, *Keramische Gebrauchskunst aus Melnik* (in Bulgarian) (Sofia, 1979), figs. 6-8.

18. Thessaloniki: C. Bakirtzis and D. Papanikola-Bakirtzis, "De la céramique Byzantine en glaçure à Thessalonique," *Byzantinobulgarica* 7 (1981): fig. 17. Philippi: from a recent excavation near the Museum. Maroneia: from the 1991 excavation of a Late Byzantine domestic area. Corinth: T. S. Mackay, "More Byzantine and Frankish Pottery from Corinth," *Hesperia* 36 (1967): 256, no. 20, fig. 1, pl. 63; G. D. R. Sanders, "An Assemblage of Frankish Pottery at Corinth," *Hesperia* 56 (1987): 173-74, no. 11, pl. 23. Skopje and Prilep: M. Bajalović-Hadži-Pešić, *Keramika u Srednjovekovnoj Srbiji* (Belgrade, 1981), figs. 135, 136, 143.

19. K. Tsouris, *O keramoplastikos diakosmos tōn ysterobyzantinōn mnēmeiōn tēs Boreiodytikēs Ellados* (Kavala, 1988), 106, fig. 83.

20. I am indebted to Prof. L. Lazzarini for informing me about this fragment.

21. A. H. S. Megaw, "Byzantine Pottery (4th-14th century)," in *World Ceramics,* ed. R. J. Charleston (London, 1968), 105-6.

22. Cvetkov, *Keramische Gebrauchskunst aus Melnik,* 5.

23. Mackay, "More Byzantine and Frankish Pottery from Corinth," 256, no. 20, fig. 1, pl. 63.

3

A NOTE ON THE HISTORY AND CULTURE OF SERRES DURING THE LATE BYZANTINE PERIOD

Charalambos Bakirtzis

Serres, a town in Macedonia in the north of Greece, ninety-five kilometers northeast of Thessaloniki, is mentioned for the first time by Herodotus (VII, 115) as *Siris*. It was the capital of Odamantice, a region north of Mount Pangaeum, where Lucius Aemilius Paulus Macedonicus pitched camp after his conquest of Macedonia (Livy XLV, 4, 2: *Sirae*). Under the empire, the town belonged to the *koinon* of the Macedonians. In the early Christian period (fourth to sixth centuries) it was the seat of a bishop, and Maximinus, Bishop of Serres, attended the Council of Nicaea in 451. The capital of the theme (administrative district) of Serres and Strymon, the town stood very close to the Bulgarian frontier, and it was particularly favored by the Emperors Nikephoros Phokas and Basil II.

When the territory of the Byzantine empire was parceled out among the leaders of the Fourth Crusade, Serres became part of the state of Thessaloniki under Boniface de Montferrat (1204). A year later, the Bulgar ruler Johannica captured and sacked the town, but after his departure Boniface refortified the citadel. The Franks were expelled in 1222 by the Despot of Epirus, Theodore Doukas Angelos, when he expanded his territory over the whole of eastern Macedonia. In 1230, after the Battle of Klokotnica, John II Asen seized Theodore Doukas's state and Serres with it, and held it until 1245, when the region fell into the hands of John Batatzes of Nicaea. When Michael VIII Palaeologos recaptured Constantinople in 1261, Serres acquired particular importance; it was restored to its position as the capital of the theme of Serres and Strymon, and enjoyed great prosperity. During the dynastic wrangling of the fourteenth century, the townspeople aligned themselves with John V Palaeologos, even though John VI Kantakouzenos owned property within the town and was coadjutor of the nearby Monastery of St. John Prodromos. In 1345, Serres fell to Stephen Dushan, ruler of Serbia. After his death ten years later, his widow Helen (Elizabeth) took over the administration of the town and the region as a whole. She was succeeded in this by John Ugljesha. Following the Serbs' defeat by

the Turks at the Evros River in 1371, the administration of Serres was taken over by the Despot of Thessalonica, Manuel Palaeologos, until the town fell decisively to the Turks in 1383.

The patriarchal Monastery of St. John Prodromos on Mount Menoikion, founded in 1275 by a monk from Serres named Ioannikios, is closely linked with the town's history (fig. 24). The interest that the Byzantine emperors showed in the monastery was continued by Stephen Dushan, and later by the Ottoman sultans. It was the spiritual atmosphere of this religious foundation that led Gennadios I Scholarios, first Patriarch of Constantinople under the Turks, to seek seclusion here, where he died and was buried in 1472.

Serres's fortified enceinte, which encloses the lower part of the town and the citadel, dates from various periods. Akropolites (ed. A. Heisenberg, 74.19) relates that in 1245 only the citadel was adequately fortified, evidently the work of Boniface. The inscription on the main tower of the citadel, "Tower of King Stephen, built by Orestes," indicates that it was built between 1345 and 1355, while reinforcements of the citadel are dated to just before the Turkish conquest.

The surviving documents in the Monastery of St. John Prodromos inform us that in the Palaeologan era there were many ecclesiastical and secular buildings in the town of Serres: monasteries, dependencies, houses, inns, workshops, and mills. All

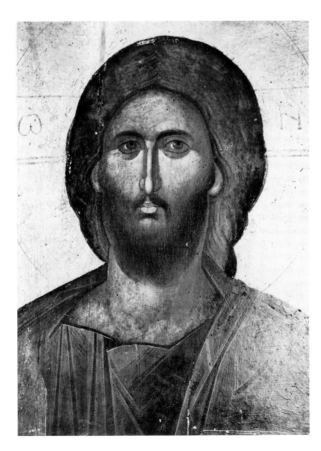

Fig. 24. Icon of Christ from the Monastery of St. John Prodromos.

that remain of these today are five churches: St. George Kryonerites (thirteenth century), St. Demetrios (early fourteenth century), the catholicon or main church of the Monastery of St. John Prodromos (early fourteenth century), St. Nicholas of the Kastro (first half of the fourteenth century), and the funerary chapel in the northwest corner of the old Cathedral of the two Saints Theodore. The chapel is believed to have been built for the tomb of Patriarch Kallistos of Constantinople, who died in Serres in 1364. The five remaining churches are all aisleless domed structures, either triconch or cross-in-square. In each, a dome covers almost the entire width of the church, making the interior as spacious as possible. This is a feature encountered in Constantinopolitan architecture, while the portico and double narthex of the catholicon of the Monastery of St. John Prodromos are reminiscent of architectural solutions employed in Thessaloniki.

The lack of surviving monuments is somewhat compensated for by a work by Theodore Pediasimos, a Serrean scholar of the first half of the fourteenth century. His *Ekphrasis tou ierou Pherrōn* is a description of the town's cathedral, whose apse was adorned with the splendid twelfth-century mosaic of the Communion of the Apostles (fig. 25). In Pediasimos's text we find the nonrational description of reality so typical of the Byzantines, allied with a classical education. That classical education was widespread in Serres in the Palaeologan era is also evidenced by a

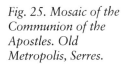

Fig. 25. Mosaic of the Communion of the Apostles. Old Metropolis, Serres.

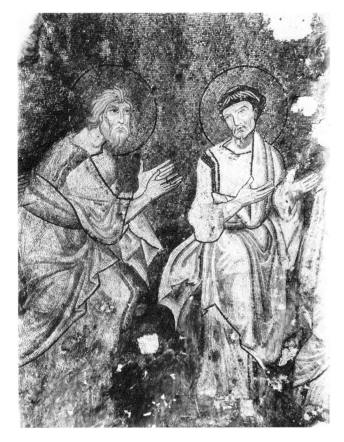

splendid archaizing funerary inscription of 1336 and by the manuscripts produced in the scriptorium of the Monastery of St. John Prodromos between 1334 and 1348.

The early fourteenth-century wall paintings in the catholicon of the Monastery of St. John Prodromos attest to the influence of antiquity, and also to the realistic expression of an anguished society. Subsequent layers of wall paintings in the same church, which are dated to a few decades later, show a distinct tendency toward provincialism. There is also a provincial quality to an impressive marble icon of Christ Euergetes, in which the high relief of earlier works is replaced by low relief (fig. 26). It was produced by a local sculpture workshop, to which we may also attribute a number of architectural sculptures from Serres.

All the miniature works, gold and silver artifacts, and embroideries known to us today from Serres are from the post-Byzantine period. There is no doubt, however, that they continue a long local tradition of handicrafts. This is confirmed by Theodore Pediasimos, who describes a devotional icon of the two Saints Theodore and refers to its silver cover, made by local smiths at the behest of Theodore II Laskaris in 1255.

It was this climate that produced the glazed ceramics of Serres, described in detail in the following catalogue.

Fig. 26. Marble Icon of Christ Euergetes. Archaeological Museum, Serres.

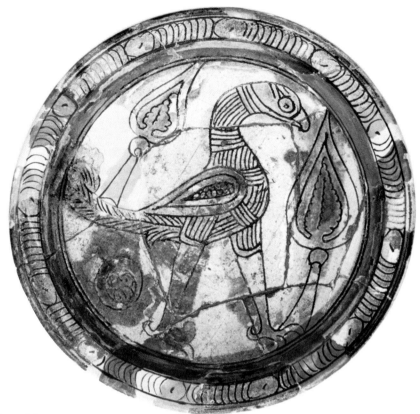

1
PLATE

H. 5.5 cm; rim diam. 20 cm;
base diam. 8.3 cm

Part of rim missing (reconstructed); glaze and slip partly flaked

Colored Sgraffito ware

Inv. no.: S.S. 1/51

Excavation site: Serres

Clay: The plate is made of fine red clay.
Shape: The base is low and flaring, the body shallow, the rim narrow and horizontal.
Decoration: White slip covers the lip and the interior. The pattern is engraved through the slip layer with a medium point. The whole interior of the plate is treated as a large medallion, filled by an impressive standing bird facing right. The bird's body suggests strength, with a long neck, a large horizontal wing shaped like a teardrop, and long tapered legs with a hawk's or eagle's large curved talons. The beak is hooked, and the eye is large and circular, with an incised pupil. The plumage is rendered by groups of parallel lines following various directions. The tail is so long that it bends back on itself, curling over at the end. A pair of spear-shaped trees, one small and one large, float above the ground in front of the bird and above its tail. Under the tail is a small medallion of the type frequently encountered as a central motif, with a trefoil. The whole composition is enclosed by double encircling lines. Around the rim is a band of twelve disks with central dots. The spaces between them are filled with parallel curved lines. Yellow-brown and green splashes enhance the sgraffito design without any attempt to follow its lines.
Glaze: The interior and the lip are covered with colorless glaze.

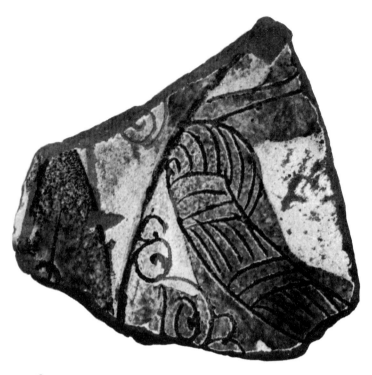

2

Fragment from the body and rim of an unfinished dish

H. (preserved) 5.7 cm
Incompletely glazed waster
Colored Sgraffito ware
Inv. no.: S.S. 7/74
Excavation site: Serres

Clay: The dish is made of red clay.
Shape: The rim is flaring with a flattened lip.
Decoration: White slip covers the interior and decorates the exterior with slip-painted circles. Engraved is a fragmentary depiction of a bird similar to number 1. Only its twisted tail is preserved. The tail is rendered with groups of horizontal and vertical parallel lines. Remains of vegetal decoration on walls and rim include spiraling tendrils. Glazed yellow-brown and green colors are splashed on the engraved pattern.
Glaze: The final coating layer of glaze is missing, since the unfinished vessel was apparently rejected as a waster at this stage.

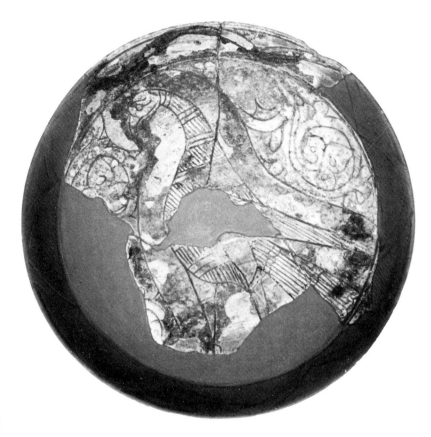

3

DISH

H. 6.7 cm; rim diam. 24 cm; base diam. 9.7 cm
Part of body and rim missing (reconstructed)
Colored Sgraffito ware
Inv. no.: S.S. 1/53
Excavation site: Serres

Clay: The vessel is made of red-to-buff clay.
Shape: A low ring base supports a shallow body with a flaring rim and a rounded lip.
Decoration: White slip covers the interior and the lip. The central axis is filled by a representation of a bird, now fragmentary, but once reaching almost from rim to rim. It is depicted in an upright position facing left and striking a leaf with its beak. The leaf belongs to a system of spiral sprigs or curving vine-stems that flank the bird and spread as a filler over the ground; the stems, with buds in their forks, encircle trefoil leaves. This bird has, under an aquiline brow, an extended eye and a hooked beak. The body plumage is rendered with alternating groups of vertical and horizontal parallel lines. Narrow single bands border the thighs of very long legs. The long wing and tail are radial, their plumage rendered by hatchings of parallel lines in continuous long strokes. Three scalloped bands cross the tail at intervals, beginning at thigh-band level and ending at the rim border, a double encircling line. A relaxed zigzag band or ribbon runs around the rim. Yellow-brown and green splashes originally embellished the sgraffito pattern in ways that are no longer fully visible.
Glaze: There is colorless glaze on the interior and on the lip.

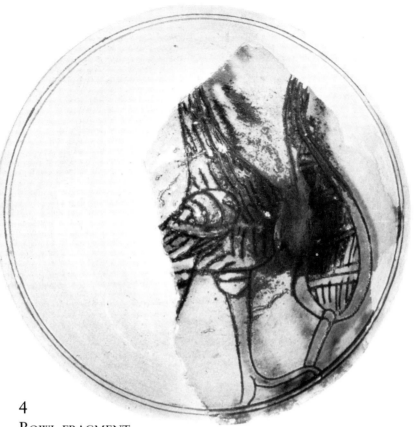

4

Bowl fragment
(in reconstructed matrix)

H. 6.5 cm; rim diam. 14.8 cm; base diam. 5 cm
Part of body and rim missing (reconstructed)
Colored Sgraffito ware
Inv. no.: S.S. 1/63
Excavation site: Serres

Clay: The plate is made of red clay.
Shape: The base is slightly raised and flaring, the body hemispherical, with thin walls and a simple lip.
Decoration: The interior is covered with white slip, and the exterior with a much thinner layer of the same slip. The entire bowl, except for the lip, serves as a field for a scene with a large (now fragmentary) bird. The bird faces right, standing on long legs with its long neck erect and its right leg at an angle, as if striding toward a curving, leaf-shaped cypress tree. The foot has only two talons, the thigh is short and rounded. The wing is teardrop-shaped and small, its plumage undifferentiated and rendered by short curved lines. Body and tail plumage are suggested by similar short but straighter lines. A double outline encloses the tree. Inside, it is hatched with small parallel lines arranged in vertical and horizontal groups. Around the lip are double parallel lines. Yellow-brown and green splashes complete the decoration. The colors are unsuccessfully fired and have merged.
Glaze: Yellowish glaze covers the interior and the lip only.

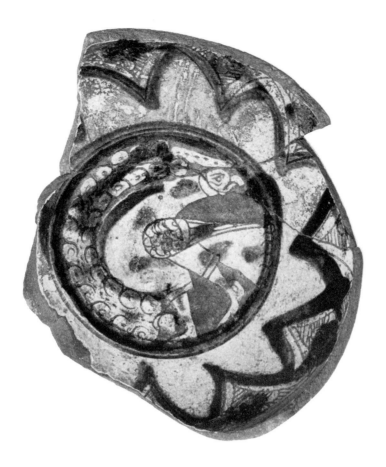

5
Bowl

H. (preserved) 8.8 cm; base diam. 8 cm
Part of body and whole rim missing
Colored Sgraffito ware
Inv. no.: S.S. 1/69
Excavation site: Serres

Clay: The bowl has a dark-fired body.
Shape: The bowl was designed with a low, flaring ring base, a hemispherical body, and, to judge by the surviving traces, a vertical rim.
Decoration: The white slip lining the interior covers the exterior with a much thinner layer. The central medallion features a bird on a cut ground (champlevé technique) walking left while turning its head to the right, so that the line of its head and body is deeply curved. A leafy branch in front of the bird follows this curve, making the whole asymmetrical scene conform perfectly to the circular shape of the medallion. Under the bowl's rim, a border of pendent triangles forms the spandrels of a continuous line of pointed petal-shaped lobes. In the triangles, incurving trefoil leaves or flowers are set against a wholly or partially hatched ground. Two parallel lines form an upper border above the triangles. Dark-fired yellow-brown brushstrokes broadly repeat the main lines of the engraved pattern.
Glaze: There is colorless glaze on the interior and some drips on the exterior.

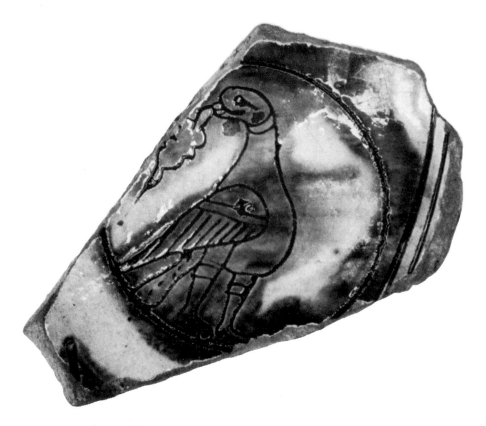

6

FRAGMENT FROM THE WELL OF A BOWL OR DISH

Maximum diam. 11.5 cm
Substantial part of body and rim missing
Colored Sgraffito ware
Inv. no.: S.S. 1/72
Excavation site: Serres

Clay: The vessel is made of red clay.
Shape: The shape, with the edge of a rim, indicates a shallow profile.
Decoration: White slip covers the interior and decorates the exterior with slip-painted intersecting circles. A medallion placed next to the rim encloses a bird, which turns its head to look back, holding a leaf in its beak. The beak is short, the eye elongated, and the neck banded by a double line. Similar bands divide the wing and underline the thighs. The plumage on the narrow tail is a dotted line, while broad hatching in a triangle indicates the lower plumage of the long wing. Alternating yellow-brown and green splashes that merge at the edges enhance the engraved pattern and enrich the decorative effect.
Glaze: Glaze covers the vessel inside and out; colorless on the interior, thinner and yellowish on the exterior.

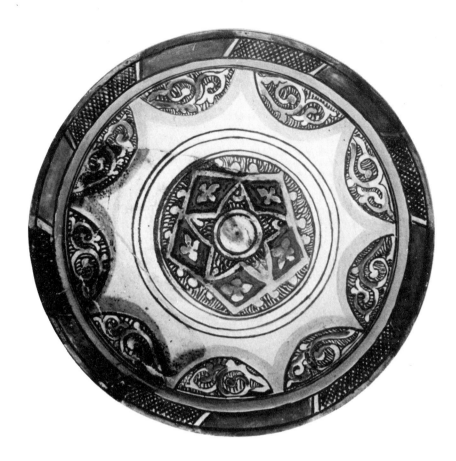

7
PLATE

H. 5.5 cm; rim diam. 24.5 cm; base diam. 9 cm
Part of body and rim missing (reconstructed)
Colored Sgraffito ware
Inv. no.: S.S. 1/50
Excavation site: Serres

Clay: The plate is made of hard red clay.
Shape: A low ring base supports a shallow body with a narrow horizontal rim.
Decoration: White slip coats the interior, with a thinner layer of the same slip covering the whole exterior. On the inside, the pattern is engraved through the slip with a medium point. In the central medallion a whirling five-pointed star encloses double encircling lines, and is contained within a pentagon. The star is surrounded by a ring of small quatrefoil rosettes set between its points, one in each angle of the pentagon. The rosettes are on a cut ground (champlevé technique). Along each side of the pentagon, three studlike protuberances stand out against the ground of the medallion, which is hatched with small, tightly packed parallel lines. Each ray of the star has a ground with similar hatching. Around the walls of the plate, nine pendent semicircles form a scalloped border, each semicircle filled with a coiled branching sprig on a hatched ground. A band with six crosshatched segments, in slanting alternation with plain segments, runs around the horizontal rim. Yellow-brown and green brushstrokes, emphasizing the main lines of the engraved design, enrich the decorative effect.
Glaze: Colorless glaze covers the interior only.

47

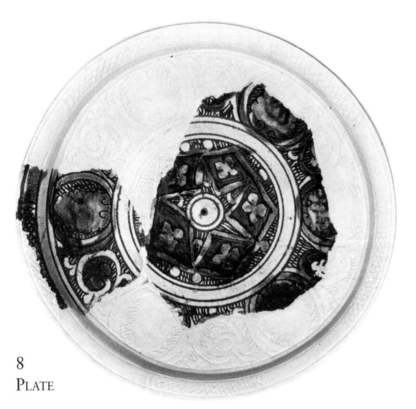

8
PLATE

H. 6.7 cm; rim diam. 25.3 cm;
base diam. 8.8 cm

Part of body and rim missing
(reconstructed)

Colored Sgraffito ware

Inv. no.: S.S. 1/54

Excavation site: Serres

Clay: The vessel is made of micaceous red clay.

Shape: A low ring base supports a shallow body and a narrow horizontal rim.

Decoration: White slip coats the interior, with a thinner layer of the same slip on the whole exterior. The pattern is engraved through the slip on the interior with a medium point: a central medallion with a pentagon containing a star surrounded by small rosettes on a cut ground (champlevé technique). The ground of the medallion and rays of the star are hatched with small, closely packed parallel lines. The star's five irregularly spaced rays frame a double circle with a firmly marked center cut through the slip. Between the rays are five quatrefoil rosettes, aligned with the points of the pentagon. Inside the star, a curved band isolates the tip of each ray. These points or tips of the star's rays are marked outside the pentagon by a series of single or paired spurs protruding into the hatched field. Two sets of double encircling lines around the medallion reduce the white field to a narrow ring bordering a broad surrounding band. In the band, enclosed palmettes alternate with trefoils on coiled stems, all on a hatched ground. Plain and crosshatched areas alternate in a band around the rim. The yellow-brown and green colors are rather dark, probably owing to overfiring of the glaze.

Glaze: Colorless glaze covers the interior only.

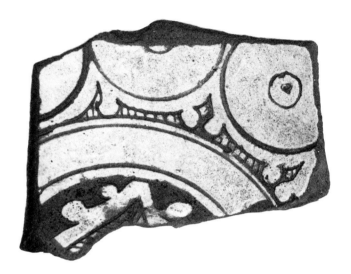

9

FRAGMENT FROM CENTER AND SIDE OF BOWL

H. (preserved) 5.5 cm
A biscuit-fired waster
Colored Sgraffito ware
Inv. no.: S.S. 5/2
Excavation site: Serres

Clay: The vessel is of red clay blackened at the core.
Shape: A ring base is the only articulated structural feature to survive.
Decoration: There is white slip all over, thinner on the exterior. On the interior, fragmentary decoration offers part of a discernible pattern. The central medallion encloses a motif in champlevé technique. Against the cut ground appears one corner of a polygon, with spurs on either side, and part of a hatched field inside. A narrow ring-shaped plain field, defined by inner and outer double encircling lines, separates the medallion from a broad band. In the band, tangential disks enclose central circled dots. The disks have spurlike protrusions from their periphery against a hatched ground. Color has not been applied.
Glaze: There is no glaze. The fragment, as a biscuit-fired waster, comes from an unfinished vessel.

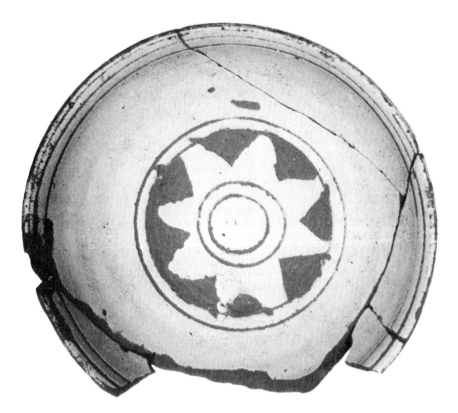

10
BOWL

H. 6 cm; rim diam. 12 cm; base diam. 5.5 cm
Part of body and lip missing;
a biscuit-fired waster
Colored Sgraffito ware
Inv. no.: S.S. 5/1
Excavation site: Serres

Clay: The bowl is of red-buff micaceous clay.
Shape: The bowl has a low ring base, a hemispherical body, and a simple pointed lip.
Decoration: The pattern engraved through white slip on the interior centers on a medallion containing a star on a cut ground (champlevé technique). The eight irregular points of the star radiate from a pair of incised and roughly concentric circles. A circular frame surrounds the cut-ground medallion, and two parallel lines run around the lip. No color has been applied.
Glaze: There is no glaze. The vessel, a biscuit-fired waster, is unfinished.

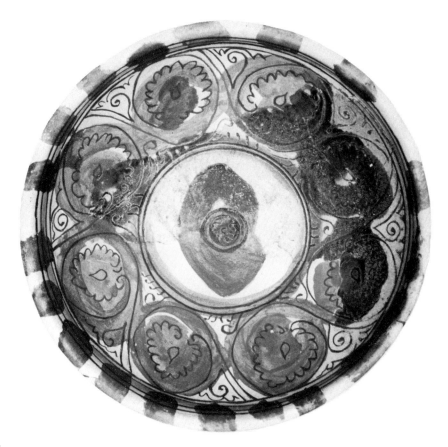

11
Bowl

H. 8.8 cm; rim diam. 19.5 cm; base diam. 8.8 cm

*Part of body and rim missing
(reconstructed)*

Colored Sgraffito ware

Inv. no.: S.S. 1/66

Excavation site: Serres

Clay: The vessel is made of red clay.

Shape: On a low ring base rests a deep hemispherical body with a vertical concave rim, a ridge between rim and body, and a flat lip.

Decoration: White slip covers the interior and decorates the exterior with circles in slip-painted technique. Inside, the pattern is engraved through the slip layer. A small central medallion inside double encircling lines holds a palmette on a cut ground (champlevé technique). Around it is a border of scrolling stems, encircling many-lobed palmette-shaped leaves with serrated edges. The spaces between are occupied by curled tendrils. Broad brushstrokes of yellow-brown and green are applied on the engraved pattern, enriching the decorative effect. The colors are rather dark and matte.

Glaze: There is colorless glaze on the interior and on the lip.

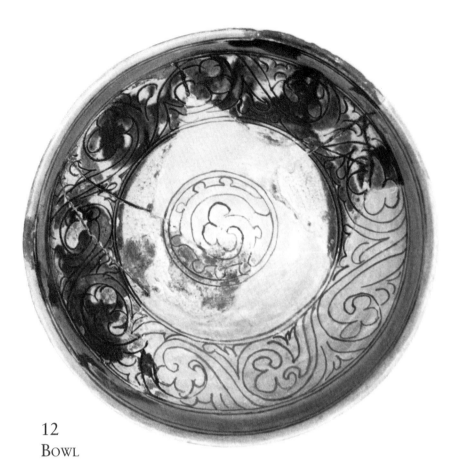

12

BOWL

*H. 9 cm; rim diam. 19.7 cm;
base diam. (estim.) 7.5 cm*

*Part of body and rim missing
(reconstructed)*

Colored Sgraffito ware

Inv. no.: R. Max./1

Excavation site: Mosynopolis

Clay: The vessel is of red clay.

Shape: The bowl has a low ring base under a hemispherical body; the rim is vertical but slightly concave, and between the rim and the body is a ridge. The lip is out-turned.

Decoration: The white slip used on the interior and on the lip decorates the exterior with circles in slip-painted technique. The interior decoration is engraved with a medium point. Half of the central medallion is preserved, with the stem of a curving spiral sprig. The medallion is surrounded by a plain ring followed by a wide band filled with a running vinescroll. The stem, turning in alternate directions around its three-lobed leaves, creates loosely filled spandrels above and below. A pair of parallel lines runs round the lip. Alternating yellow-brown and green touches enhance the engraved decoration.

Glaze: There is a colorless glaze, showing greenish yellow from retouching with yellow glaze color, on the interior and the lip only.

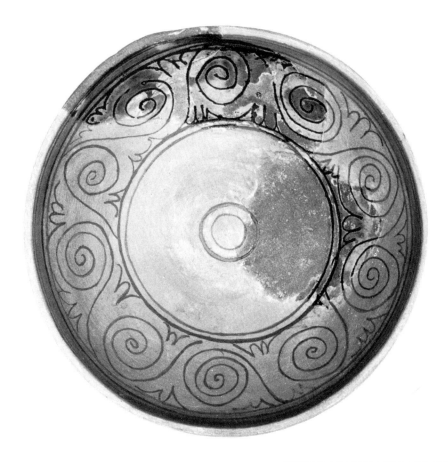

13
Bowl

H. 7.8 cm; rim diam. (estim.)
19.5 cm; base diam. 9 cm
Substantial part of body and rim missing
(reconstructed)
Colored Sgraffito ware
Inv. no.: S.S. 1/68
Excavation site: Serres

Clay: The body is made of red micaceous clay.
Shape: The base is a low ring. The hemispherical body has a vertical, concave rim and a rounded lip. There is a ridge between the body and the rim.
Decoration: There is white slip on the interior and on the lip. In the center, two concentric arcs indicate reconstruction as a spiral or a pair of concentric circles, surrounded by a broad, plain field and a broad band. In the band a stem scroll forms a running spiral with pairs of flanking double-budded forks pointing alternately up and down. Pairs of encircling lines border the rim. The potter has enriched the decorative effect by alternating bright yellow and green splashes without bothering to follow the engraved pattern.
Glaze: A colorless glaze covers the lip and the interior only, but both slip and glaze are badly flaked, leaving large bare areas.

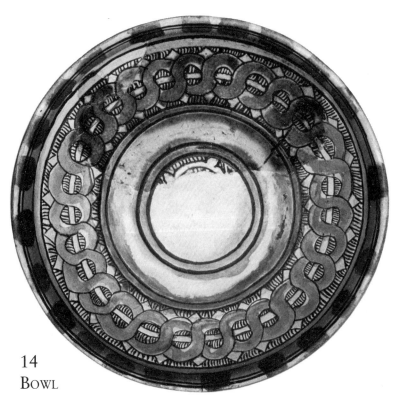

14
BOWL

H. (preserved) 8.2 cm; rim diam.
(estim.) 20 cm; base diam. 9.2 cm

Part of body and rim missing
(reconstructed)

Colored Sgraffito ware

Inv. no.: S.S. 1/67

Excavation site: Serres

Clay: The bowl is made of dark-fired red clay.
Shape: The base is a low ring, the body hemispherical, the rim vertical and concave, with a ridge between it and the body.
Decoration: White slip covers the interior and decorates the exterior with slip-painted circles. The fragmentary central medallion originally included a foliate design (probably an incurving sprig) on a hatched ground. Broadly engraved double encircling lines surround the medallion; another pair of lines, around the walls, underlies a broad band filled with guilloche on a hatched ground. The guilloche overlies a circular ribbon and is connected to concentric circles on either side by angular points in the inner and outer spandrels. Two parallel lines closer together border the lip. Extremely bright yellow-brown and green brushstrokes mostly following the sgraffito design enrich the decorative effect. Outside the medallion the double encircling lines make a yellow-brown ring; the next ring outward is green followed by the golden chain of the yellow-brown guilloche. The ribbon, the points, and the hatched ground are left uncolored for contrast. On the lip, yellow is dominant, in multiple radiating strokes, in sets with green strokes between them.
Glaze: There is a colorless glaze overall, inside and out.

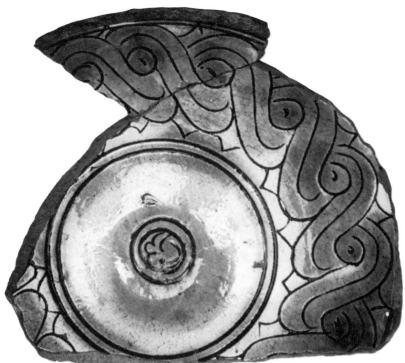

15
FRAGMENT OF A BOWL

H. (preserved) 6 cm; base diam. 9 cm
Substantial parts of body and rim missing
Colored Sgraffito ware
Inv. no.: S.S. 1/79
Excavation site: Serres

Clay: The bowl is made of red clay.
Shape: A low ring base surrounds a nipple. The body is hemispherical. There was probably a vertical concave rim.
Decoration: White slip is used on the interior. A small central medallion inside a frame of two engraved circles is filled with a trefoil sprig on a curved stem. Around the medallion is a plain field, and further out a broad band with a double-strand guilloche. The coils of the guilloche are centered with dots, and their spandrels, above and below, have angular fillers. A double encircling line defines the outer limit of the band. Bright yellow-brown and green color enhances the engraved pattern, following its main lines in concentric alternation. The green touches the sprig at the center; the yellow flows outward from the medallion. Then green outlines the circle at the base of the yellow guilloche. Inside the guilloche, green touches the central nodules as a stabilizing color opposed to the mobile, ongoing yellow.
Glaze: The interior is covered by shiny colorless glaze.

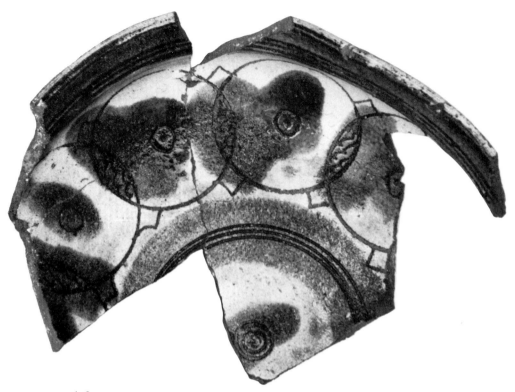

16

FRAGMENT OF A BOWL

H. 8 cm; rim diam. (estim.) 18 cm;
base diam. (estim.) 7.7 cm
A waster of the final firing
Colored Sgraffito ware
Inv. no.: S.S. 1/82
Excavation site: Serres

Clay: The vessel is made of red clay overfired to gray.
Shape: A low ring base supports a deep hemispherical body under a vertical concave rim with a rounded lip. The vessel, a waster of the final firing, is deformed owing to overfiring and crackled due to lime inclusions that have exploded.
Decoration: The pattern is engraved through white slip on the interior. A central spiral is surrounded at a distance by three concentric circles. Around the walls runs a broad band with a chain of interlocking disks. At the center of each disk is an engraved dot ringed by a small circle. The arcs where the disks interlock are textured by a broad imbricated hatching; above and below it an angular point marks the spandrels. Four parallel lines run around the rim. Yellow-brown and green brushstrokes enhance the decoration. The colors are dark owing to overfiring.
Glaze: Very thin, colorless glaze is found on the interior only.

17
BOWL FRAGMENT

H. (preserved) 4 cm;
base diam. 7.3 cm
Walls and rim missing; a biscuit-fired waster
Colored Sgraffito ware
Inv. no.: S.S. 1/77
Excavation site: Serres

Clay: The bowl is made of red clay.
Shape: The base is a low flaring ring.
Decoration: The interior is covered with white slip. Through it at the center a spiral was cut while the pot was turning on the wheel. A triple circle, cut in the same way, separates the well of the bowl from the wall. No color has been applied.
Glaze: There is no glaze. The vessel, a biscuit-fired waster, is unfinished.

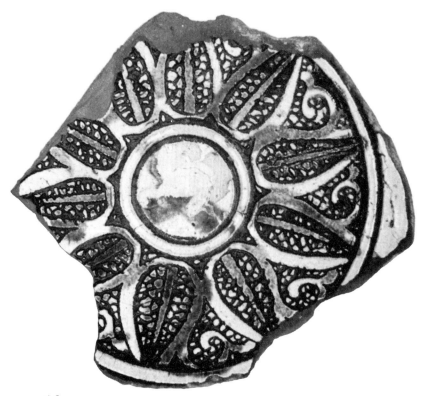

18

CENTER OF A BOWL OR DISH

H. (preserved) 3.5 cm: base diam. 7.7 cm
Rim and part of body missing
Colored Sgraffito ware
Inv. no.: S.S. 1/70
Excavation site: Serres

Clay: The body is made of hard red clay.
Shape: The base is low and flaring. Nothing of the rim remains.
Decoration: The white slip covering the interior coats the exterior in a thinner layer. The decorative pattern is engraved with a rather broad point. A double encircling line encloses a band around a medallion empty of engraved ornament. Beyond, leaflike motifs and coiled stems radiate across a scale-patterned ground, giving the overall impression of a rosette. The leaflike units are shaped like teardrops or pointed petals with cropped tips; the left side of each one forks into the coiled stem that fills the spandrel with a calligraphic gesture. Rather dark alternating yellow-brown and green brushstrokes complete the decoration.
Glaze: There is colorless glaze on the interior.

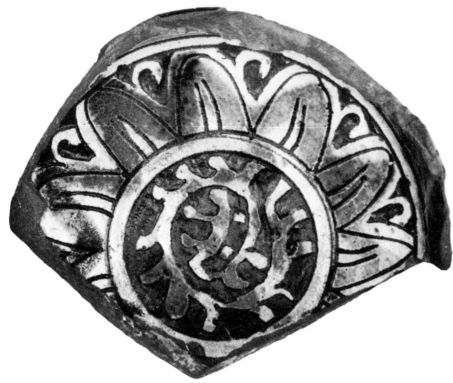

19

FRAGMENT OF A BOWL

H. (preserved) 5.2 cm; base diam. 8 cm
Part of body and rim missing
Colored Sgraffito ware
Inv. no.: S.S. 1/80
Excavation site: Serres

Clay: The body is made of dark-fired red clay.
Shape: The base is low and ring-shaped with a nipple; below the rim the body is shallow and flat. To judge by the surviving traces, it is likely to have had a vertical rim.
Decoration: White slip covers the interior and decorates the exterior with dots. The pattern is engraved through the slip on the interior in champlevé technique, while some details are executed with a medium point. In the central medallion a sprig coils inward, bristling with leaves. Around this medallion, a ring of radiating leaves with midribs bending to the left is bordered by a double line. The spandrels between the leaves are filled with thick, hooked tendrils turning to the right. On this bowl the strong contrast between the dark body and the white slip sets the stage on which the colors enhance the engraved motifs. Green dapples the coiled sprig at the center, and a broad, wavy, yellow-brown stroke overlies the leaves, roughly following their shape.
Glaze: Colorless glaze covers the interior, and yellow glaze the exterior.

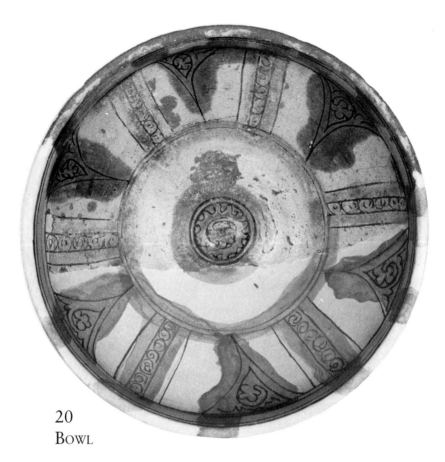

20
BOWL

*H. 8.2 cm; rim diam. 19.5 cm;
base diam. 8.5 cm*

*Part of body and rim missing
(reconstructed)*

Colored Sgraffito ware

Inv. no.: S.S. 1/55

Excavation site: Serres

Clay: The bowl is of red clay.
Shape: The bowl's low flaring base supports a deep hemispherical body with a vertical concave rim; it has a ridge between the rim and the body, and a flat lip.
Decoration: The pattern is engraved through white slip on the interior with a rather fine point. There is a small central medallion with a spiral sprig enclosing a palmette inside a serrated leaf or ring. Radiating around it is a band in which pendent triangles alternate with subdivided strips. Each triangle contains a stem with a trefoil or quatrefoil on a coiled stem. Each strip, divided vertically into three, is filled with a central string or chain of loose tangential spirals. Double encircling lines run around the lip. Yellow-brown and green brushstrokes enhance the engraved design, emphasizing its alternation and articulating the division into fields.
Glaze: Thin colorless glaze covers the interior of the vessel.

21
BOWL

H. (preserved) 6.8 cm; base diam. 8.3 cm
Substantial part of body
and rim missing
Colored Sgraffito ware
Inv. no.: S.S. 1/73
Excavation site: Serres

Clay: The vessel is made of red clay.
Shape: The base is low and flaring, and the body hemispherical, with a vertical rim.
Decoration: The white slip is applied on the interior only. All that remains of the central decoration is a triple ring of fragmentary concentric circles. Radiating around it in a wide band are wavy vegetal lines, alternating with a curved-sided lozenge motif. The surviving lozenge is composed of three concentric units framing a three-lobed flower. Round spiraled terminals extend from the four corners of the lozenge. Yellow-brown and green enrich the decoration, with a green stroke in the area of the center, a yellow streak around the triple ring, green marking the radial dividers, and yellow covering the lozenge.
Glaze: A thin layer of colorless glaze covers the interior.

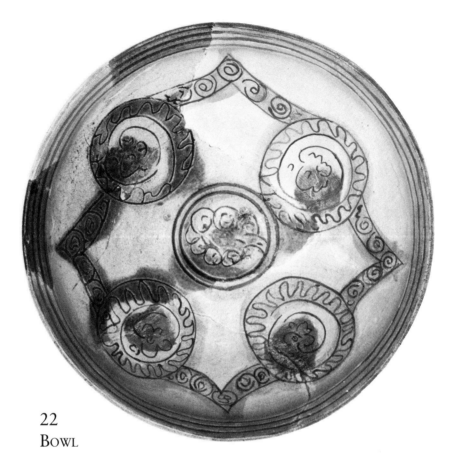

22
Bowl

H. 8.5 cm; rim diam. 18.8 cm;
base diam. 7.5 cm

Substantial part of body and rim missing
(reconstructed)

Colored Sgraffito ware

Inv. no.: K.Ph. 16/90/10

Excavation site: Philippi

Clay: The clay is red blackened on the exterior face.
Shape: The base is low and ring-shaped with a nipple. The hemispherical body has a vertical concave rim and a rounded lip.
Decoration: White slip covers the interior and decorates the exterior with slip-painted circles. The floral motif in the central medallion is a cluster on a thick curved stem. A double encircling line frames the medallion, which was apparently surrounded by four other medallions. In each of them a serrated ring around a coiled stem enclosed a floral motif vaguely suggestive of a palmette. Angled bands filled with spirals join these circles together in a bulging octagon. Four parallel lines form a border inside the rim. Alternating brushstrokes of yellow-brown and green outline the circles and spread into their centers, following the main lines of the incised design. Color fills the border inside the rim.
Glaze: Colorless glaze covers the interior and the lip.

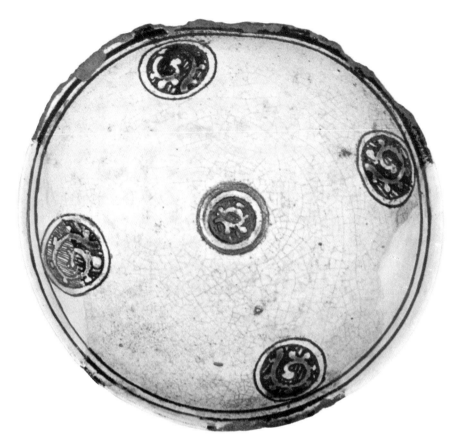

23
BOWL

H. 5.3 cm; rim diam. 14.5 cm; base diam. 5.3 cm
Part of body and lip missing (and reconstructed in part)
Colored Sgraffito ware
Inv. no.: R.M.P. 91/144
Excavation site: Maroneia

Clay: The vessel is made of red clay.
Shape: A low, slightly flaring base with a nipple supports a hemispherical body with a simple lip. The vessel is slightly deformed.
Decoration: White slip covers the whole vessel inside and out. The interior slip is engraved with decoration in the form of five small medallions. The medallions mark the center of the bowl and the four corners of an imaginary square. They all contain curved sprigs on a hatched ground. The sprigs bristle with budlike leaves on the outside of the stem. Two parallel lines run around the lip. Only the five medallions are touched with color, which in this case is exclusively yellow-brown.
Glaze: There is colorless glaze on the interior and on the lip.

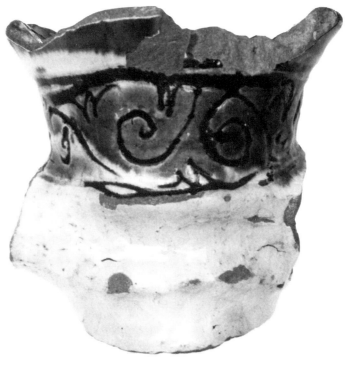

24

MOUTH AND PART OF THE NECK
OF A CLOSED VESSEL

H. (preserved) 6.5 cm; rim diam. 6 cm
Colored Sgraffito ware
Inv. no.: S.S. 1/87
Excavation site: Serres

Clay: The vessel is made of red clay.
Shape: The mouth is funnel-shaped, with a rounded lip turning out. Below the rim are traces of two opposed handles.
Decoration: White slip is used on the exterior and the lip. Near the top a band is filled with a running spiral. Its coiled outlines and the buds in the forks point alternately up and down. Bright yellow-brown and green splashes alternate on the engraved design.
Glaze: There is colorless shiny glaze on the exterior and on the interior of the rim only.

25

FRAGMENT OF A HANDLE
FROM A CLOSED VESSEL
(A JUG?)

Maximum diam. 12 cm;
width 5 cm
Colored Sgraffito ware
Inv. no.: S.S. 1/78
Excavation site: Serres

Clay: The fragment is of red clay.
Shape: The form is band-shaped and slightly curved.
Decoration: There is white slip all over. A broad band is filled with a double-strand guil-
loche. Embellishing the coils are small rosettes at their centers and teardrop buds in their
spandrels. Alternating yellow-brown and green splashes are applied to the engraved pattern.
Glaze: There was colorless glaze all over, but part of both slip and glaze has flaked off.

4

THE MATERIALS ANALYSIS OF
BYZANTINE POTTERY

Sarah Wisseman

ANALYTICAL TECHNIQUES

Understanding the location and layout of ceramic production sites is essential to tracing the history of a particular type of pottery and following its development from raw material to finished product. The archaeologist is interested in the potential sources of clay, temper, and fuel for firing as well as patterns of distribution and trade of the fired pottery. Installations such as kilns and levigation tanks reveal not only the details of manufacturing technology, but also the scale and organization of production. Wasters—the overfired, underfired, or otherwise unusable discards found near kilns—are crucial pieces of evidence because of their undisputed source. Their appearance and chemical composition are controls for other pottery found both at the production site and further afield.[1] The sourcing of pottery by a combination of traditional typology, microscopic analysis, and chemical composition is usually termed a *provenance* (also "provenience") study. Here, the term provenance refers to the original manufacturing site of the ceramic ware rather than its findspot in modern times. By contrast, provenance of stone (e.g., obsidian) usually refers to the source (location of the outcrop) of the raw stone.

Sources of raw clay used in antiquity are difficult to identify because of the variable nature of clay. Clay is a hydrous aluminosilicate that contains minor impurities such as oxides of iron and calcium in different amounts. The chemical composition of clay can vary within the same clay bed, depending on the rainfall, history of deposition, and amount of nearby vegetation.[2] Raw clay changes chemically over time due to wind and water movement, making modern identification of original clay sources even more problematic. Also, the tempering and firing of clay can alter its composition so that a final product bears little resemblance to its source clay.[3] For all these reasons, archaeologists usually rely on comparative analyses of fired ceramics to determine manufacturing sites.

Although petrography, a microscopic technique borrowed from geology, yields useful information on the structure of the clay and temper and their constituent minerals, analysis of the minor and trace elements is often necessary to distinguish between two visually similar fabrics. Techniques for multielemental analysis include optical emission spectroscopy, X-ray fluorescence, and neutron activation. While all three methods provide usable chemical profiles of pottery, many American analysts prefer neutron activation analysis (NAA) because it characterizes up to thirty-five major, minor, and trace elements in a single run. Another advantage of NAA is that it requires only tiny samples: about 100 milligrams of pulverized clay. These samples can be scraped or drilled from the underside of a pot or from the edge of a sherd, leaving only a small hole so that the piece can still be displayed in a museum setting.

The major disadvantage of NAA is that it requires a nuclear reactor. Pulverized clay samples are bombarded by neutrons inside the reactor, causing some of the nuclei for each element to form radioactive isotopes. These unstable isotopes decay with characteristic half-lives, emitting gamma rays whose energies can be measured. These measurements yield a chemical profile like a genetic "fingerprint" of the quantities of each element present in the sample.

Neutron activation analysis, although expensive, has been used with great success on a variety of pottery types.[4] Byzantine pottery such as the wares found at Serres has only recently been analyzed chemically. The method used by Megaw and Jones was optical emission spectroscopy.[5] Pottery (including some sgraffito), wasters, and tripod stilts associated with kilns at seven sites in Greece and Cyprus were run. The resulting reference groups of compositional data for pottery of secure provenances can eventually be compared to trade wares and other pottery of uncertain origin.

ANALYSIS OF SERRES POTTERY

Twenty-two samples of colored sgraffito wares from Serres were submitted for compositional analysis at the reactor facility of the University of Illinois. Most of the samples were from bowls and plates. Sarah Wisseman of the Program on Ancient Technologies and Archaeological Materials (ATAM) took 100-milligram samples from the edges of each sherd, using a tungsten-carbide drill burr that was cleaned in alcohol each time to prevent clay mixing. Two sherds, sample numbers 11 and 21, were drilled twice in different places to test for clay homogeneity within a single pot. The powder was loaded into small vials and given to Sheldon Landsberger of the Department of Nuclear Engineering for neutron activation analysis.

The resulting compositional data for major, minor, and trace elements for all samples except number 22 (lost in handling) were clustered by William Cizek, a graduate student in computer science, using a statistical program called SPSS and several forms of agglomerative hierarchical clustering.

The results of these analyses suggest that the potters of Serres were using clay from at least three distinct clay sources (see fig. 27). It should be noted, however, that this result could occur if the potters were tempering some clay but not all of it,

or if they were using different temper in different clay batches. Further analysis may reveal the exact type of temper used. Another explanation might be that the potters gathered clay from different parts of the same clay bed, especially if clay from preferred locations was depleted over time.[6] The apparent distance between the samples 11a and 11b, and between 21a and 21b is difficult to explain unless either the clay fabric for samples 11 and 21 is not homogeneous or there was an error in handling or sampling. Finally, the suspected wasters, samples 18 and 9, appear near each other in every cluster, although 9 is clearly distinct. Its chemistry may have been altered due to exposure to higher temperatures or more prolonged firing than the other sherds.

GLAZE ANALYSIS

Prior research on Byzantine pottery has concentrated on the composition of the clay fabric rather than its surface pigments and glazes.[7] Since one of our sherds preserved a large patch of glossy green glaze, we decided to test it for its coloring agents. Copper and iron oxides were expected, with lead in the overglaze. A second sample with well-preserved white slip was also selected to test the slip composition, and both pieces were given to Duane Moore, a clay mineralogist at the Illinois State Geological Survey. Dr. Moore reports that X-ray diffraction reveals that both the

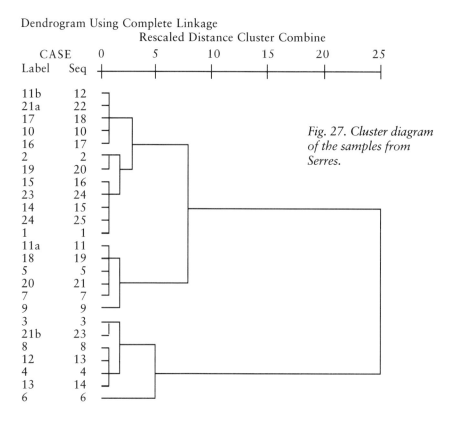

Fig. 27. Cluster diagram of the samples from Serres.

68

green glaze and the white slip contain elpasolite. He notes: "Elpasolite ($K_2Na_4Al_4F_{24}$) is a relatively uncommon mineral; a good candidate for a tracer component. However, this should be considered a tentative identification. My guess is that something like CaF_2 was used as a flux to lower the melting temperature and elpasolite was formed during the firing process. Another possibility is that a deposit of cryolite (Na_3AlF_6) was available to the potters and they used that somehow in making their pots. Elpasolite is apparently an alteration product of cryolite."[8] The green glaze is mostly a glassy material, with subequal amounts of elpasolite and quartz, while the white slip has not much glass, about 90 percent elpasolite and 2 percent to 5 percent quartz. The clay fabric for both sherds is nearly identical: predominantly quartz with minor amounts of mica, K-feldspar, plagioclase, and perhaps a trace of kaolinite. Results of X-ray fluorescence analysis will be presented in a subsequent publication.

NOTES

1. J. Gunneveg, I. Perlman, and J. Yellin, *The Provenience, Typology and Chronology of Eastern Terra Sigillata,* Qedem, Monographs of the Institute of Archaeology, Jerusalem, 17 (1983).

2. E. L. Will, "The Sestius Amphoras: A Reappraisal," *Journal of Field Archaeology* 6 (1979): 345.

3. P. M. Rice and M. E. Saffer, "Cluster Analysis of Mixed Level Data: Pottery Provenience as an Example," *Journal of Archaeological Science* 9 (1982): 395-409.

4. P. M. Rice, *Pottery Analysis: A Sourcebook* (Chicago, 1987); M. D. Glascock, "Characterization of Archaeological Ceramics at MURR by Neutron Activation Analysis and Multivariate Statistics," in *Chemical Characterization of Ceramic Pastes in Archaeology,* ed. H. Neff (Madison, Wis., 1992), 11-26.

5. A. H. S. Megaw and R. E. Jones, "Byzantine and Allied Pottery: A Chemical Analysis," *Annual of the British School at Athens* 78 (1983): 235-64; R. E. Jones, *Greek and Cypriot Pottery: A Review of Scientific Studies,* The British School at Athens, Fitch Laboratory Occasional Paper, 1 (Athens, 1986), 743-45; L. Lazzarini and S. Calogero, "Early Local and Imported Byzantine Sgraffito Ware in Venice: A Characterization and Provenance Study," in *Archaeometry: Proceedings of the 25th International Symposium,* ed. Y. Maniatis (Amsterdam, 1989), 571-84.

6. Will, "The Sestius Amphoras," 345.

7. Jones, *Greek and Cypriot Pottery,* 743-45.

8. D. Moore, personal communication (letter dated April 24, 1992). For more information on elpasolite, see C. Frondel, "New Data on Elpasolite and Hagemannite," *American Mineralogist* 33 (1948): 84-87.

GLOSSARY

Apotropaic: Intended to divert evil, from the Greek for "turning away."

Biscuit: Clay that has been fired but not glazed; also called bisque.

Champlevé: From the French for "raised field," a pottery technique of cutting away the slip surface around a unit of design to make it stand out in low relief with a positive-negative contrast of figure and ground; a term derived from enameling.

Earthenware: Baked clay (terracotta, glazed or unglazed) that is distinct from porcelain and stoneware, being low-fired and porous.

Engraving: In metalwork, a technique of linear design in which the working tool cuts away the surface along its path, so that engraving differs from mere scratching or incising, which divides the surface without removing any of it. Traditionally, however, even when the same technique is followed in removing the slip layer, sgraffito ware has been called incised.

Flux: A melting material such as lead, used as a major component of glaze to make it fuse during firing. See *Lead glaze.*

Glazing slip: See *Lead glaze.*

Guilloche: A regularly looped or twisted double or multiple strand with eyelike nodules inside the turnings.

Late Byzantine: A conventional term for Byzantine art of the thirteenth through fifteenth centuries.

Lead glaze: A transparent, glassy finish, with lead flux, applied to pottery to make the surface impervious to liquid. The lead flux lowers the melting point of silica in the glaze, fusing with it to form a thin layer of glass.

Leather hard: A semi-dry stage achieved before pottery is fired.

Levigation: A process for purifying potter's clay; when mixed with water, the fine particles remain suspended, while the coarser ones sink to the bottom.

Luster: The application of metal oxides over the glaze to produce a metallic surface decoration; copper luster's tone is golden.

Middle Byzantine: A conventional term for Byzantine art produced between 843 (the end of iconoclasm) and 1204 (the capture of Constantinople by the Fourth Crusade).

Neutron activation: A procedure using a nuclear reactor to characterize the elemental composition of clay in order to trace the clay to its source.

Nishapur: An important medieval city and commercial center in Khorasan, in northeast Iran.

Palaeologan dynasty: Byzantine imperial dynasty ruling from 1259 to the end of the empire, in 1453.

Post-Byzantine: Dating after the fall of Constantinople to the Turks, in 1453.

Rods: Earthenware supports inserted in the walls of kilns to separate glazed pottery during firing.

Samarra: Abbasid capital on the Tigris, founded in 836.

Sgraffito: From the Italian for "scratched," the technique of engraving or incising through a surface layer of white or cream-colored slip, cutting down to the underlying clay to create a contrasting design.

Sherd: A fragment of broken pottery.

Slip: Clay thinned with water to a consistency that lets it flow or allows it to be used as paint; also called engobe.

Three-color ware: Lead-glazed polychrome earthenware (*sancai*) from Tang China, developed to its "classical phase" in about the first half of the eighth century A.D.; the original colors of clear brown and green were later supplemented with red and blue.

Throwing: The shaping of clay as it turns on the potter's wheel.

Tin glaze: An alternative to lead glaze, chosen for its whiteness in Iraq and on Mediterranean proto-maiolica ware.

Tripod stilts: Earthenware supports used to keep glazed vessels from sticking together when fired in vertical stacks in the kiln.

Wasters: Discarded pottery, rejected as faulty during production.

X-ray diffraction: A technique requiring powdered samples, used to identify minerals and other crystalline phases found in ceramics, metal, and stone.

X-ray fluorescence: A nondestructive surface analytical technique used to determine multielemental composition of ceramics, glass, metal, and stone artifacts.

Zeuxippos ware: A type of red-bodied twelfth- and early thirteenth-century sgraffito ware of high quality found in various sites from the Black Sea to Cyprus and named after examples found in the Baths of Zeuxippos in Constantinople.

SELECTED BIBLIOGRAPHY

Bajalović-Hadži-Pešić, M. *Keramika u Srednjovekovnoj Srbiji.* Belgrade, 1981.

Bakirtzis, C. "Didymoteichon: un centre de céramique post-byzantine." *Balkan Studies* 21 (1980): 147-53.

Bakirtzis, C., and D. Papanikola-Bakirtzis. "De la céramique Byzantine en glaçure à Thessalonique." *Byzantinobulgarica* 7 (1981): 421-36.

Cvetkov, B. *Keramische Gebrauchskunst aus Melnik* (in Bulgarian). Sofia, 1979.

Déroche, V., and J.-M. Spieser, eds. *Recherches sur la céramique byzantine.* Bulletin de Correspondance Hellénique, Suppl. XVIII. Athens, 1989.

Dimitrov, D. "Rabotilnica za trapezna keramika vův Varna." *Bulletin de la Société Archéologique à Varna* 11 (1960): 111-17.

Guillou, A. *Les archives de Saint-Jean-Prodrome sur le mont Ménécée.* Paris, 1955.

Iakobson, A. L. *Keramika i keramičeskoe proizvodstvo Srednevekovoj Tavriki.* Leningrad, 1979.

Jones, R. E. *Greek and Cypriot Pottery: A Review of Scientific Studies.* The British School at Athens, Fitch Laboratory Occasional Paper, 1. 1986.

Lazzarini, L., and S. Calogero. "Early Local and Imported Byzantine Sgraffito Ware in Venice: A Characterization and Provenance Study." In *Archaeometry: Proceedings of the 25th International Symposium,* ed. Y. Maniatis, 571-84. Amsterdam, 1989.

Mackay, T. S. "More Byzantine and Frankish Pottery from Corinth." *Hesperia* 36 (1967): 249-320.

Megaw, A. H. S. "Byzantine Pottery (4th-14th Century)." In *World Ceramics,* ed. R. J. Charleston, 105-6. London, 1968.

———. "An Early Thirteenth-Century Aegean Glazed Ware." In *Studies in Memory of David Talbot Rice,* ed. G. Robertson and G. Henderson, 34-45. Edinburgh, 1975.

—————. "Zeuxippus Ware." *Annual of the British School at Athens* 63 (1968): 67-88.

Megaw, A. H. S., and R. E. Jones. "Byzantine and Allied Pottery: A Contribution by Chemical Analysis to Problems of Origin and Distribution." *Annual of the British School at Athens* 78 (1983): 235-63.

Morgan, C. *Corinth, XI, The Byzantine Pottery.* Cambridge, Mass., 1942.

Notopoulos, J. "Akritan Iconography on Byzantine Pottery." *Hesperia* 33 (1964): 108-33.

Orlandos, A. "Ē mētropolis tōn Serrōn kata tēn Ekphrasin tou Pediasimou." *Epetēris Etaireias Byzantinōn Spoudōn* 19 (1949): 259-71.

Ostrogorski, G. *Serska oblast posle Dušanove smrti.* Belgrade, 1965.

Papageorgiou, P. N. "Ai Serrai kai ta proasteia ta peri tas Serras kai ē monē Iōannou tou Prodromou." *Byzantinische Zeitschrift* 3 (1894): 225-329.

Papanikola-Bakirtzis, D. "The Tripod Stilts of Byzantine and Post-Byzantine Pottery" (in Greek). In *Amētos,* Volume in Honor of Professor Manolis Andronikos, 641-48. Thessaloniki, 1986.

Rice, D. T. *Byzantine Glazed Pottery.* Oxford, 1930.

Sanders, G. D. R. "An Assemblage of Frankish Pottery at Corinth." *Hesperia* 56 (1987): 159-95.

Ševčenko, N. P. "Some Thirteenth-Century Pottery at Dumbarton Oaks." *Dumbarton Oaks Papers* 28 (1974): 353-60.

Spieser, J.-M. "La céramique byzantine médiévale." In *Hommes et richesses dans l'empire byzantin,* vol. 2, *VIIe-XVe siècle,* ed. V. Kravari, J. Lefort, and C. Morrisson, 249-60. Paris, 1991.

—————. "Le monde byzantin. La céramique, nouvelles approches." In *Le grand atlas de l'archéologie,* ed. C. Flon, 144-45. Paris, 1985.

Stevenson, R. B. K. "The Pottery, 1936-1937." In *The Great Palace of the Byzantine Emperors,* vol. 1, 31-63. Oxford, 1947.

Xyngopoulos, A. *Ai toichographiai tou katholikou tēs monēs Prodromou para ta Serras.* Thessaloniki, 1975.

—————. *Ereunai eis ta byzantina mnēmeia tōn Serrōn.* Thessaloniki, 1965.

A NOTE ON THE AUTHORS AND CONTRIBUTORS

DEMETRA PAPANIKOLA-BAKIRTZIS is curator at the Ephoreia of Byzantine Antiquities in Kavala, Greece. She is the author of *Medieval Cypriot Pottery in the Pierides Foundation Museum* and numerous articles on Byzantine pottery in scholarly journals such as *Balkan Studies, Bulletin de Correspondance Hellénique,* and *Byzantinobulgarica.*

EUNICE DAUTERMAN MAGUIRE is curator at Krannert Art Museum of the University of Illinois at Urbana-Champaign. She has published articles in *Dumbarton Oaks Papers* and in *Byzantinische Forschungen.* She is the coauthor, with Henry Maguire and Maggie J. Duncan-Flowers, of *Art and Holy Powers in the Early Christian House,* and has served as editor and contributor to a number of catalogues of exhibitions at the Krannert Art Museum.

HENRY MAGUIRE is director of Byzantine Studies at Dumbarton Oaks, Washington, D.C., and Professor of Art History at the University of Illinois, Urbana-Champaign. He is the author of *Art and Eloquence in Byzantium, Earth and Ocean: The Terrestrial World in Early Byzantine Art,* and numerous articles in scholarly journals such as *Gesta, Dumbarton Oaks Papers,* and the *Art Bulletin.*

CHARALAMBOS BAKIRTZIS is ephor at the Ephoreia of Byzantine Antiquities in Kavala, Greece. He is the author of *Byzantina tsoukalolagena* and numerous articles on Byzantine archaeology.

SARAH WISSEMAN is assistant director of the Program for Ancient Technologies and Archaeological Materials of the University of Illinois at Urbana-Champaign.